All best wishes for the
Years to Come —
Leitka
Spring 2020

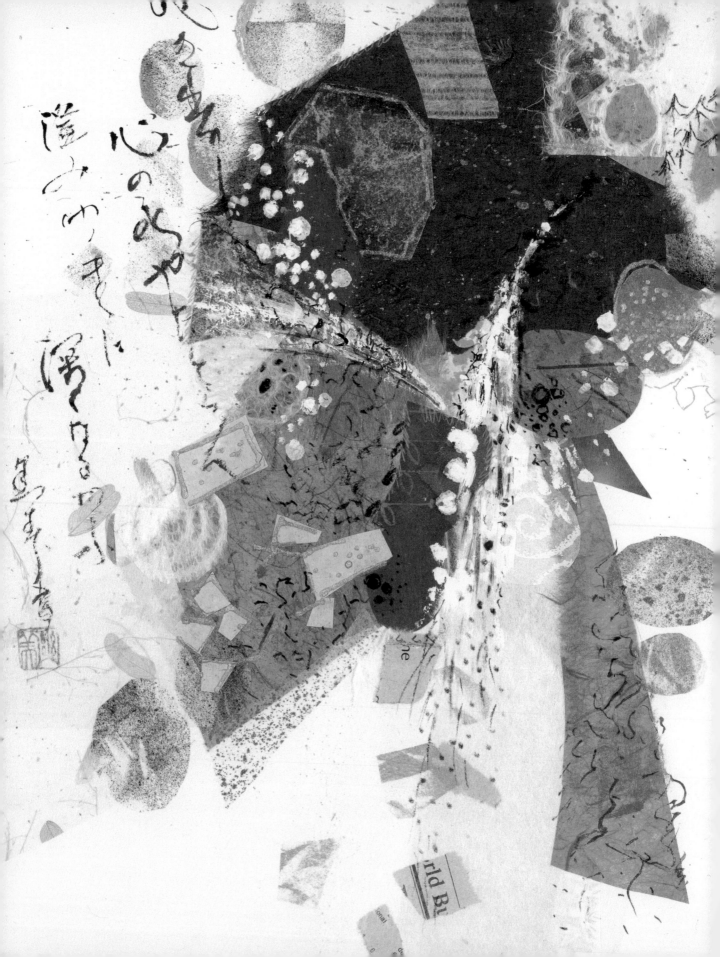

Persimmon and Frog

My Life and Art,
a Kibei-Nisei's Story
of Self-Discovery

FUMIKO KIMURA
with **DAVID BERGER**

CHIN MUSIC PRESS Seattle

Contents

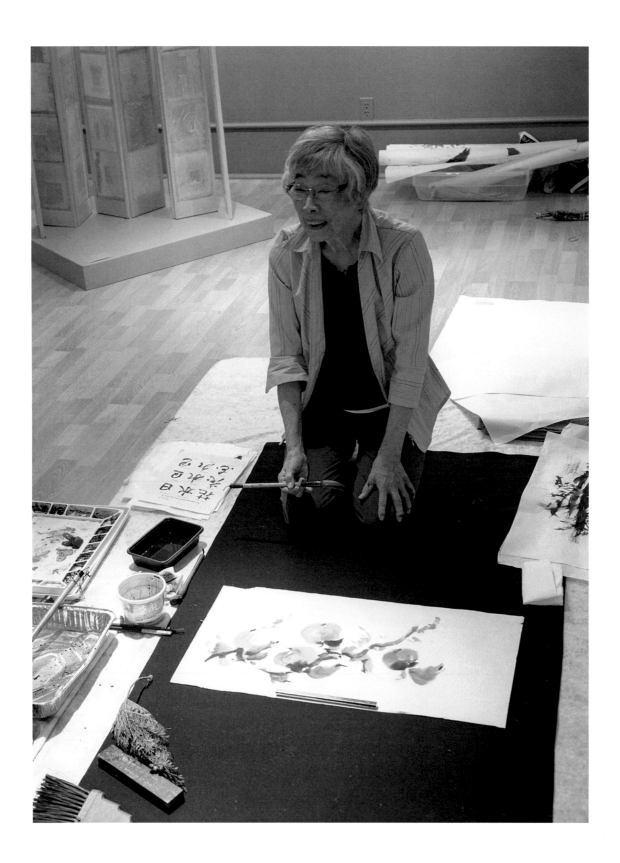

Introduction

I first met Fumiko Kimura when I joined Puget Sound Sumi Artists (PSSA). She was a charming septuagenarian artist, and one of the founders of the organization. She generously offered sumi painting and collage classes to PSSA members for free, and also volunteered at schools and senior centers, demonstrating the joys of sumi painting and calligraphy using the Japanese brush and ink.

I learned in her classes to load my brush with three-color ink—that is, light, medium, and dark—and absorbed her admonishments to paint from the heart with directness and intuition. I watched her grow into her eighties and show little sign of slowing down from a busy schedule of making art, exhibiting, and encouraging others with supportive words.

Over time I became familiar with parts of her life journey, and her desire to write a memoir or autobiography. I knew parts of her story and as a writer and artist was intrigued, and thus came about a multi-year collaboration that was a pleasure. From Kimura's diaries, snippets of her writing, and interviews the manuscript was born.

Occasionally I would discuss her life story with friends. "She was the eldest daughter of Japanese immigrant parents . . ." They would interrupt knowingly. "Oh, and she and her parents were rounded up and sent to an internment camp." No. That harsh sequence did indeed happen to about 120,000 people of Japanese heritage when WWII came to America. But Kimura's trajectory is less familiar. Instead of forced relocation and incarceration, she by happenstance spent the war years in Japan, a preteen American who looked completely Japanese. Her parents had taken their children back to Japan with a one-year visa to meet the maternal grandparents, and the visa was extended for another year after her mother contracted tuberculosis. Then Pearl Harbor occurred and the family was stranded. Kimura thus spent ages ten to seventeen in rural Japan, seven formative years in Miyagi prefecture going to the local school and helping with the rice farming. Her forced sojourn in Japan was a complicated experience made worse by estrangement from

Fumiko Kimura demonstrating painting and calligraphy in 2013.

her father. But Kimura was resilient and determined. She absorbed and adapted to Japanese culture, and thrived.

At seventeen, she took a boat back to America with a younger brother while her parents and two siblings stayed behind. Thus Kimura, in addition to being Nisei—an American born to Japanese immigrants —was also Kibei, literally "return to America." The term refers to Americans of Japanese heritage who were raised or educated in Japan and then repatriated. Back in her homeland, Kimura faced new social complexities. Some Americans resented Japanese Americans, and some Japanese Americans, better integrated into American customs, shunned her more Japanese ways. There were more than ten thousand Kibei during this period, a slice of the Japanese American experience not much known to the general public or well studied by academics, and her story is a contribution.

You might think her unsettled childhood would give rise to a disrupted sense of identity, but Fumiko's determination, self-sufficiency, and modesty allowed her to hold the tiller firmly and steer her life even from an early age. After the war, back in America, she made her way. Relearning English, she graduated college and became a chemist doing technical and research work. She married a Japanese American man and raised a family. In her forties she abandoned her safe career to pursue a passion for painting. That had been her joy even as a young girl. Accomplished in Western-style watercolors, she found her way back to a Japanese sensibility. She had memories of doing calligraphy and Asian-style painting from decades earlier in Japan. She discovered a public television program offering instruction in Japanese brush painting, and was delighted to learn from the flickering TV screen in her living room. It only whetted her appetite for more. Although she was the family's primary breadwinner, she determined to go back to school against her husband's wishes in order to fully pursue life as an artist. She never doubted she could change careers, return to school, and still provide for her family. And she did.

She became an influential artistic figure in the Pacific Northwest and founded Puget Sound Sumi Artists in the mid-1980s with her friends Mary Bottemley, a calligrapher, and Ann Inouye, a teacher of ikebana. Her artworks are sometimes light-hearted and sometimes undergirded with darkness, and they sway between abstraction and representation, reflecting her predilections and history. Sometimes they are overt, and other times subtle and concealed. More than sixty years of art-making are contained in this book, covering a lot of emotional ground and formal explorations. I'm partial to some of the most recent works, with

abstract lines based on ballet dancing, and the calligraphies of uplifting words, like "compassion," as well as some of the collages with poems written in flowing Japanese script. But the rambunctious energy and pleasing colors of the earlier works are seductive as well. Kimura is not really a classic sumi artist painting vignettes with black ink and leaving lots of white space. Instead, she has found and pursued her own varied path in art, just as she has found her own determined, optimistic, and resilient path through life.

The book has three sections. The first focuses on her life story. The second is an art section with a survey of her artwork and profiles of her themes and projects. The last section brings her life story to the present. Throughout there was a natural inclination to link her life and art as that is how Kimura approached it, though neither explains nor reduces to the other.

David Berger
SEATTLE, JULY 2019

Today I collected rainwater in the backyard. The purity of the water was important to me. It suggested other kinds of purity, of behavior and of the soul. I mixed the clean, pure water with Nikawa glue, making a kind of resist. I painted the mixture onto rice paper and let it dry. I then made ink, grinding the ink stick on a large suzuri stone. I dipped the brush in the ink and touched the point to the dried resist. The ink spread in a circle, blooming on the paper.

—Yumi (aka Fumiko Kimura)

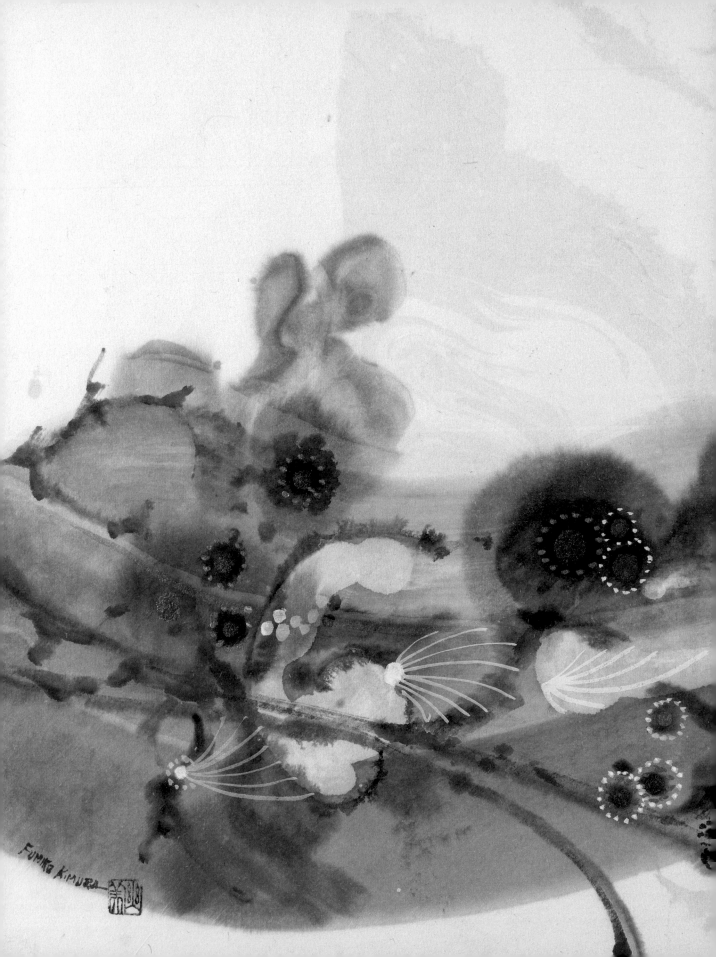

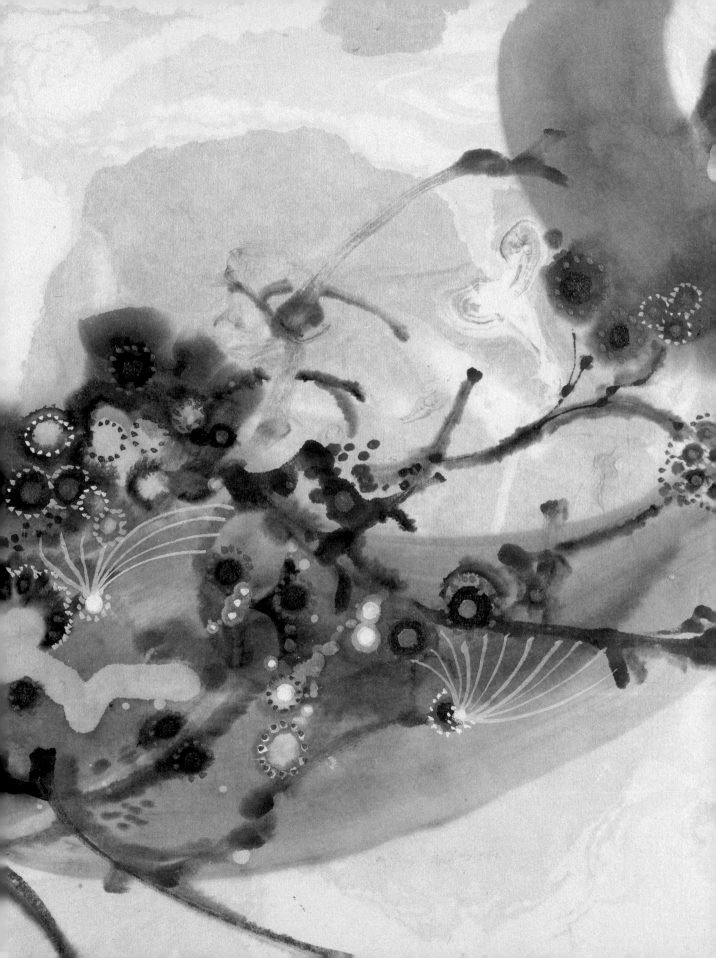

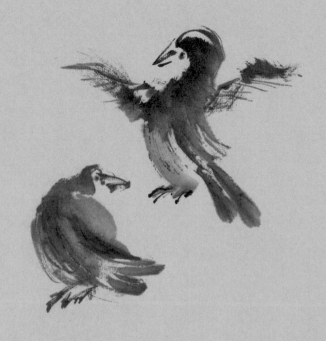

PART ONE

Life

a bent shoot
rises through the morning mist
springtime

—D.B.

Early Years

1929–1940, TO AGE 10

I came into the world on December 21st, 1929, in Rexburg, Idaho. It was the winter solstice, the shortest day of the year. Was that auspicious or inauspicious? I don't know. Mother and I came home from the hospital to find an empty house. My father wasn't there. My mother, Yoshiko Fukui Takahashi, always told me stories and I used to listen with awe. This was one of them: She came home with her little baby on a cold winter day and no father. I don't know where he was. She never said. He wasn't drinking. He was allergic to alcohol, just like me. Father disappeared for a while from time to time, as my mother told me, but a family friend, Mr. Kanomata, came to see us, traveling through the snow on horseback to make sure my mother and I were OK. I can picture his horse with snorting breath in the icy air, and myself, a tiny American citizen born to Japanese immigrant parents. Winters are cold in the southeastern Idaho farmland, and mother used to tell me that my nose was always red, even in front of the fireplace. My parents lived in a rented house and worked for a farmer who grew potatoes and sugar beets. Mother helped in the fields and in season drove to neighboring families selling produce house by house. It was a hard life and the beginning of the Depression.

This was my mother's second marriage. She had been living in Tacoma, Washington, when she divorced. Her husband returned to

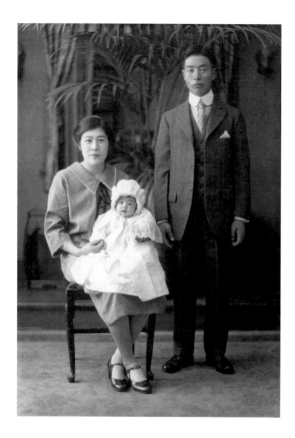

Here I am one year old in 1930 with my parents: Kahei Takahashi, father, and Yoshiko Fukui Takahashi, mother.

Japan with their son, my half-brother, Yoshiharu Shimamoto. Their daughter, Kimiye, stayed with Mother in Tacoma. Mother later married my father, Kahei Takahashi. The three of them moved to California. Here is another story Mother told me: Father never allowed Kimiye to sleep with them on their bed. Kimiye slept on the floor with bedding that was made up each night. She was only two or three years old when a playmate pushed her down a rocky hill near the ocean. She spent several days in the hospital, then died. Mother said that in hospital Kimiye was finally able to sleep on a bed.

After this event, my parents moved to Idaho where I was born, and my brother George and sister Fusae followed quickly. When I was three years old, the family moved again, back to California, to Gardena, a suburb of Los Angeles. We leased a one-story farmhouse with an outhouse and ten acres of land. We grew string beans, celery, and lima beans. Soon after arriving, my youngest brother, Gene, was born. So there were four of us. I was the oldest. Japanese was spoken at home. We attended elementary school during the week and on Saturdays, Japanese language school.

We were a traditional family. My father was very strict. If things were not done just right, he was like "thunder and lightning," as a saying in Japan goes when it comes to fathers, and we kids were fearful. We all had chores and one of mine was to start the meal, cooking rice before Father and Mother came home from the vegetable fields. We cooked on a kerosene stove. I was lighting the stove one day in April when my dress caught fire. The flames were just suddenly engulfing me. I was ten years old. I screamed and ran outside and rolled on the yard. It was so hot on my skin. My brother George got a towel and pounded to extinguish the flaming material. I was burned on my chest, abdomen, leg and back. I was sent to a children's hospital in Los Angeles where I spent four months. There were lots of children there with whom I became friendly. I was always the social sort. I had two skin grafts, a painful process. I returned home with scars over twenty-percent of my body and a list of exercises to keep the skin flexible for my continued growth. You couldn't see the scars. They were on my torso and hidden by clothes. But after

I returned from the hospital, my father thought I was not normal. He started calling me deformed, a freak. It came out of his mouth all the time. He was angry and he spoke these angry, hurtful words. Freak. Disfigured. It was a verbal thing. We never got spanked. I erected a wall and stopped talking to him after this. I would respond with a few words if necessary, but never initiated conversation. I thought that it was all my fault that I was burned. Honestly, the scars didn't bother me till Father made it an issue. Mother was protective. She comforted me after Father's outbursts. She was hard-working on the farm and felt bad that she had let me start the kerosene stove at such a tender age. Father accused her of not teaching me how to use the stove correctly. I blame the manufacture of the match, as it seemed the head flew off as I struck the metal stove and it landed on my dress bursting in flames. In my mind that's what I remember happening, some eighty years ago.

Leaving for Japan
1940, AGE 10

I was in the hospital recovering till mid-August, and then just three months later, in November 1940, we took a boat for Japan on a long-planned trip to visit to my maternal grandparents. We had a one-year visa. I was a fifth-grader just shy of eleven. We went to Japan to meet the grandparents and learn about our roots and Japanese traditions. My parents were Issei, first-generation immigrants, and I and my siblings were Nisei, second-generation. It was typical for Issei to want their children to know about Japanese culture, and send or take them to Japan. We lived south of Tokyo in Yamaguchi prefecture near the southwestern tip of the main island Honshu with my mother's parents. It was a one-story house in a rural area only a 10-minute walk to the coast, and we enjoyed playing by the water. In the springtime, cherry-blossom season, my mother contracted tuberculosis. It was a non-contagious variety, but she could not return to the United States and so the visa was extended for another year. It was hard on me after Mother got sick. The daily household

This photo was taken in California just before we kids embarked to meet our grandparents in Japan in 1940. From left to right, George, eight years old; Gene, five; myself, the eldest, at ten; and Fusae, seven. Our ages are noted on the back of the photo.

responsibilities fell to me. I had to get up early to prepare breakfast and do housework. On weekends I did the family laundry.

At a certain point we moved from one end of the island to the other, from the southwestern corner to the northeast, to Inaoki village near Sendai city in Miyagi prefecture. My paternal grandparents had a house there, and after they died the house passed to my father, their oldest son. So we inherited a place to stay in the north and asked the renters to leave. It was farming country with rice paddies in the lowlands and vegetables growing on the hillsides. The rice paddies extended for miles, and in fall the ripening rice was like a golden sea. Father had land for growing rice along with the house, six *tan*, about one-and-a-half acres. The house was two stories, typical of houses in the area, without insulation or a heating system. We all slept upstairs in one large room. In winter we huddled under a futon around the traditional *kotatsu*, a sunken brazier, in the downstairs living area. Water came from a well, and for bathing there was an outdoor metal tub in a little outbuilding. We would light a fire with twigs and sticks to heat the water, wash and rinse with bucket and sponge, and use the tub for a short soak. It was evident we would be in Japan for a while. We kids registered for elementary school in Inaoki village, first having to become Japanese citizens to do so. We thus had dual citizenship.

My mother liked to sew. She had brought her heavy treadle sewing machine to Japan when we had left the United States for the year. Her lifelong dream was to teach teens and adults how to sew, and have a school, however small. When my father proposed marriage to her, a divorcee with a small child, she had asked about her sewing, and my father supposedly said, "of course you can . . ." Mother taught me how to sew, explained things to me in a gentle manner, and was always worried about my physical health due to the burn accident and scars. My first project was a vest made from bits of leftover material. It was very colorful and everyone thought only a crazy person would wear that kind of clothing. This was the rural area where we were living when Japan attacked Pearl Harbor and the United States declared war against Japan and entered World War II just a few weeks before my birthday, in December 1941. As a consequence we couldn't go home to America and were stranded in Japan. History had swept us up in its tight grip.

I don't remember if my parents were happy or sad. They did sigh about things, my father especially when the war broke out, as if to say, oh no, it happened. We kids were very innocent. When Japan was winning, advancing in the war, we rooted for them. Until the Allies started winning in the Philippines and Pacific Islands, and bombing Japan. Then

we were rooting for America. But there was always the sense that we would go back to America, and not stay in Japan, whether Japan won or lost the war.

In Japan
1940–1947, AGE 10–17

My life at school in the countryside began in the third grade, the appropriate level for my Japanese-language comprehension. I was older than my Japanese classmates by more than a year and always the tallest girl. I wore a button-down blouse, sweater, skirt, and leather shoes while the local children, both boys and girls, wore dark kimonos over trousers with belt and *geta*, the traditional wooden footwear. My siblings and I were looked upon and teased as "blue-eyed Americans," even before the war started. Our American clothes really stood out. It was the clothing, not the face, because of course I looked completely Japanese. "Go back to America" was the bullying we received. They spoke the local dialect, which was entirely different from the standard national language. Being called a blue-eyed American didn't bother me at all. But my brothers didn't like being bullied. I knew my brother George was especially upset about it. He was more sensitive. Because he was upset I was upset.

Third-grade school was difficult at first. I sat there in silence and didn't say a word. One day in the spring, the teacher asked who would like to read the lesson from the textbook. I raised my hand after months of silence. The teacher, Mr. Ishibashi, who was also vice principal of the elementary school, called my name to read. *Takahashi Fumiko*. I stood up slowly but not shy and read the chapter we were studying. All eyes were directed at me as if to say, "she can read Japanese!?" Actually I knew all along what we were learning since I had attended Japanese school in California. After that, I was no longer a "blue-eyed American" and was invited to play hopscotch and jump rope.

My confidence and life in school improved. With warmth and support from my teacher, Mr. Ishibashi, I was on my way, finding myself as a local country girl with the Biblical words "soar high on wings of hope" ringing in my ears. I had those words on my mind all the time.

Fourth Grade in Japan
STARTING TO PAINT

School in the fourth grade was separated into boys' and girls' classes. Mr. Ishibashi was the girls' homeroom teacher. He taught us all curricula except for gym-exercise. We were in school six hours a day Monday through Friday, and Saturday classes ended at noon. Mr. Ishibashi was a professional photographer and specialist in painting and calligraphy. He asked a few boys and girls from the elementary classes to stay after

school and gave us lessons in watercolor. He had a vase of flowers and other objects ready. There were no verbal instructions. I thought that was strange. He just demonstrated and then said, "Now it is your turn, paint." We did as he said. My arrangement was more detailed than Mr. Ishibashi's. I observed more darks and lights and painted with more colors, showing how the color changed in different light. I was really attracted to color. I learned a lot even though there was no explanation except to watch how he used the brush and watercolors. I had fun doing it. I had no idea it was to be my life's work.

Growing up as a young girl in Japan I knew my teachers well and appreciated what they taught me. I'll never forget the teachers. So kind. Maybe they were father figures for me. They are stuck there in my heart.

Fifth & Sixth Grade in Japan
1942–1943, AGE 12–13

Life in fifth and sixth grade years continued to give me a sense of belonging as I was using the local dialect and playing with my classmates. These were the two years everyone needed to study hard in order to be accepted to junior and senior high school in the city some miles away. I continued with watercolor painting with Mr. Ishibashi for another year until he left for a different elementary school. Miss Ishikawa was our new homeroom teacher. She was insistent that we study more at home. She gave us a lot of homework. Not everyone would advance from the sixth grade. Most would attend two more years at the village elementary school, graduate as eighth graders, and become family farmers. I was

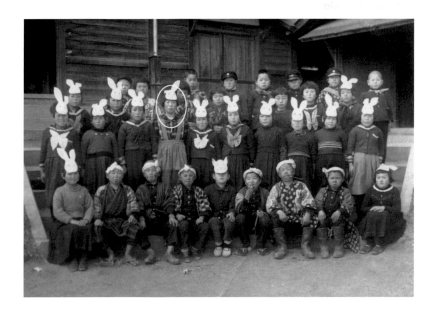

Despite WWII, school and normal activities continued. In 1943, the school produced three plays. This was the cast for "Life of White Rabbit."

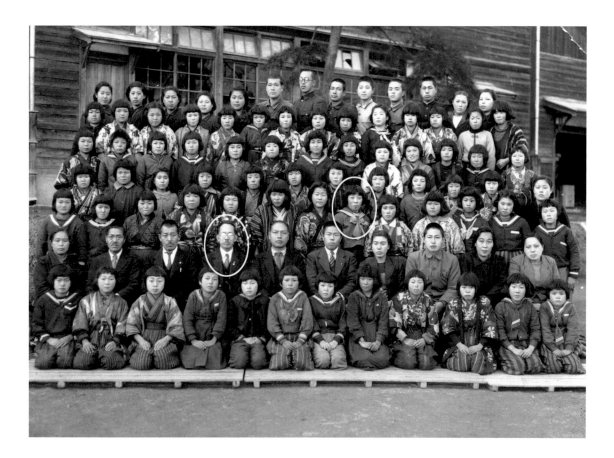

I'm wearing sailor's clothes. That was the school uniform for those who could afford it. Mr. Ishibashi, also circled, was vice principal of the school and taught me watercolors after official school hours.

fortunate to pass the written and oral exam and so was able to attend Kakuda girl's high school.

The war meanwhile was continuing. Food was in short supply. We sixth-graders and others were sent out after lunch in the fall to catch grasshoppers. The rice was maturing, about knee high. We walked through the fields on raised dirt pathways, flushing out grasshoppers. I had a hard time catching them. They'd jump up and disappear. But Fusae, my sister, was very good at collecting them. We put them in cotton bags Mother had made from sewing scraps. Fusae always had a full bag, while mine would be only half full. Back at school after a couple of hours of hunting, we all put our grasshoppers into a large pot hanging over a wood fire. Then we received a portion to take back home where they were prepared with soy sauce or other flavorings and eaten with the evening meal of rice. They were crunchy with hardly any taste. I didn't like them much.

Seventh & Eighth Grade and Crystals

1944–1945, AGE 14–15

Kakuda girl's high school was located a good distance from my home. As a seventh-grade student I walked thirty minutes to the bus stop, rode on the bus for thirty minutes, and then walked ten more minutes to the school. Classes were divided into two or three sections of thirty to forty students each; they came from all the different surrounding country areas.

Every school day I was up at 4:30 a.m., preparing breakfast for the family, cooking rice and vegetable soup, packing rice and sour pickled plum into square tins for the school lunch, and cleaning house. Then I walked to the bus stop. However, on snowy winter mornings the bus was always late, so I just walked to school the whole way. I left around six a.m. and walked one hour up the hill, and then another hour along the bus line to arrive at my first class on time. The sky was dark and my breath was white, but due to snow the atmosphere was bright. My brother and sister waited for the bus to arrive. They always arrived late to school. I had to get there on time. I didn't want to miss my first class. Even at this young age, I was very determined. I wanted to go to school and make something of my life.

There were separate teachers for different subjects. The students ranged from young seventh graders to mature, friendly, twelfth graders. Students gave pet names to the most popular teachers. Mr. Ashina, the science teacher, was tall, and his head was asymmetrical with a little dent. We called him, "imo-chan," potato head. Mr. Watanabe, the geology teacher, was called "kuma-chan," bear, due to his seeming Ainu origin and brown complexion. Another popular teacher, Mr. Uyeda, who taught civics, was called "Nolakuro," after a comic book character that was popular at the time.

One day, Mr. Ashina invited me to the laboratory after school and dissolved tiny blue crystals in a beaker of warm water. Then he suspended a string and invited me to come back the next morning. Oh my gosh. I had never seen anything so gorgeous as those large blue crystals that had formed overnight, faceted like gems and crowded on top of one another. Their beauty overwhelmed me. He asked me to make crystals at home by dissolving table salt in a dish with water and placing it under the roof where a breeze might be found. In a few days I saw a layer of white crystals had formed in the dish. I felt the beauty and mystery of the world at my fingertips.

All through junior high school, I was invited to stay after school twice a week with another student a year younger to paint with Miss Onuma. She showed us how to paint thistles, making the pink filaments stroke by stroke with a thin brush. This was my introduction to ink painting with color as well as the style of Nihonga, a method based

on traditional Japanese painting, adapted from the Chinese style Gongbi, which emphasizes realism and precise details.

One time, Miss Onuma brought a magazine with a picture of a Picasso painting, a still life with vase and bottles. She said, "Copy this and bring it back in two weeks." It was nice to stay late at school to do art, painting still lifes or going outdoors to paint landscapes, rocks, and flowers, and be away from the work at the farm and all the household chores. Even during the summer two or three of us students were invited to paint. That was fun. No other students were around, and maybe just one teacher in the office.

When I could, I went walking on the hillside behind our house for some privacy and to be alone with my thoughts. There were trees and in the fall it was especially pleasant. I kept a diary and sat on a stump and wrote. I wrote about my classmates and my problems with them, the burdensome chores, and copied the poems of famous Japanese writers that I admired. I had many favorites. I well recall the dappled light pushing through the trees, the rustle of the leaves, and the colors of the sunset. I heard the *uguisu*, the famous Japanese nightingale, singing in the branches, *hohooo-hokekyo*, many times.

School Stops and the War Ends
1944–1945, AGE 14–15

World War II of course was raging on. Money and goods were in short supply. Shoes were delivered in bulk to the school with distribution to those who were most in need. The rice crop was closely regulated. After the harvest in late October, we had to report how much we grew. The government took it all, and we got a small amount back as a ration.

Occasionally my father caught a fish in the river near our house, or a pheasant; he had a license to hunt in the woods. In the fall we had grapes and chestnuts, and Toyama persimmons that had to be peeled and dried to become sweet and edible. We made exchanges with neighbors. My younger brothers would hunt for small birds like sparrows, setting up a bamboo screen in the yard. It was a drop of protein and kept them busy. There was never any pork or beef, or other meat.

Each morning I formed the rice balls in the palm of my hand for us children to take to school for lunch, with a little pickled plum, *umeboshi*, in the center for flavor and saltiness. They were little larger than golf balls and not enough. We were always hungry. I sometimes made my rice ball a little larger and snuck it into my lunch tin, compressing it down hard so it wouldn't be obvious. We often had to extend the rice with sweet potatoes, a mixture I didn't like at all since it made the texture gooey.

One day classes stopped. The upper grade students, the eleventh and twelfth graders, were dispatched to factories where war needs were manufactured. Some stayed in a nearby dormitory and worked locally. Younger students like myself stayed at home, carrying shovels and hoes to distant hillsides and clearing areas for growing food. Many were bitten by bees that lived in the rocky soil.

As the war continued, we watched American planes going overhead. Sendai city was bombed at night. We could hear explosions. It was ten *li* away, three or four miles, but we could hear the bombs and see bright lights in the sky. It was scary. Our feeling was, maybe it is our turn now. Our houses might burn, or we would die.

A soldier's wife, son, and mother-in-law lived in our small house during the last year or so of the war. The three of them lived in one room. They had their own plates and cooked on a charcoal fire outside the house. Many families found refuge in the countryside as Tokyo and other cities were bombed. People went wherever they could find space. They used our bedding, which was stored in their room in a tokonoma alcove.

The war ended in August of 1945 as citizens heard the voice of the Emperor on the radio. We had a radio on the shelf in the dining room. Father was there, Mother was there, and I was there, listening. No one had heard the Emperor's voice before. He had a strange voice and an old-fashioned way of speaking. I didn't understand the way he used words, but my parents did. I was excited and felt privileged to hear the Emperor.

Mainly his speech was a declaration of surrender, and focused on his concern for sparing further suffering and more lives lost to atomic bombs. The atomic bombs were down south in Hiroshima and Nagasaki, so we didn't know about that. We were in the north. We were happy the war was over because of all the hardships. My father was smiling. We were all relieved because there was never enough food.

I remember one time before the war ended, Father asked us kids who ate one of the precious persimmons being dried. There were only five persimmons on the string while he had left six to dry. We could not have our dinner until someone confessed. I was desperate to have dinner and study the next day's school assignment. Since no one said anything, after a while I volunteered and said, "I ate it," when I had not eaten even a bite. Father was happy because I confessed and was truthful. We got to eat our dinner, and I to study. Thanks to that confession I completed my schoolwork. Was I wrong to make that sort of confession? I was glad he didn't yell at me. Father was friendly and charming to outsiders, but

at home he was moody. When Father was in a bad mood, he shouted at me and my brother George, and always ended his tirades by saying, "you freak" to me. If he was angry about some job we did around the yard, his comment to me was "LOOK at you!" in Japanese, *ZAMAA miro*. Those were the times I felt bad about my scars. My concerns were mostly about my daily activities, and the back and forth interactions with my class-mates, as my diary of the time reports. I had friends and participated in school events. I felt normal inside, as normal as an adolescent could feel under the circumstances.

Still, though my diary does not record my thoughts about the scar-ring, I do remember how I felt. Feelings do come back, or maybe never go away, with experiences as traumatic as the ones I suffered. I don't need a diary to recall always being embarrassed when wearing a swim-suit. I would look for a swimsuit to cover my upper legs for swimming in physical education class, but none was ever long enough. I never learned to swim. I felt very much at times that I was deformed, a freak as my father announced. I felt rejected and lonely. I ignored it, and him, as best I could and was self-sufficient, staying busy in school and after school. That could be why I enjoyed pursuing painting, working on my own and coming home just in time to start the dinner, regardless of tal-ent or not.

Growing Rice

1945–1947, AGE 15–17

Tenth grade, after the war, was stressful due to many uncertainties. It was time to return to the United States, but the months rolled by and we continued living in Japan. My parents wanted us kids to go back to the US, thinking they would follow. Japan was a small, constrained coun-try in my mother's estimation. She always told me, "You will go back to the United States and make your life there." She knew the opportunities America could give and wanted us to be there.

Meanwhile, Father had his rice field to take care of. Mother was not getting any better from her tuberculosis, still coughing and having fevers, however she was able to do sewing for neighboring families at her own pace, making money, and taught a neighbor friend named Mitsue-san who suffered depression after the birth of her third child. She came to see Mother on a *liacaa*, a two-wheeled cart, "delivered" by her hus-band for a change of scenery. My brother George and I helped with rice culture. My brother Gene was too young to help, and Fusae was not only young but always whimpering about the chores and saying, "Let's go back to America." She was kind of sickly and never acclimated well to Japan or Japanese customs.

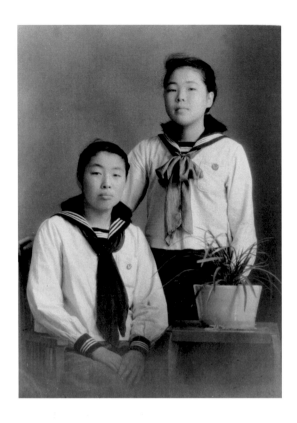

I'm on left and my best friend, Midori Mori, is on right. I studied art with her after school, that's how we became friendly. I was to leave shortly for the United States.

All through the growing season, neighbors got together to plant the rice seedlings that had been nurtured in early spring in the pond. I learned to plant seedlings three or four at a time within my row marked off by string. Leeches often bit me during the planting. They would fill themselves with blood till round like marbles and then drop off. Luckily I was never infected. Weeding was done during the summer. Father, my brother George, and I did the weeding. The more the fields were weeded the better the harvest, but it was grueling work and we barely made it through weeding twice. We weeded by hand in the mud. Dirt wedged under my fingernails, impossible to remove. In fall I watched the adults cutting and harvesting, and drying the rice bundles on bamboo racks. A neighbor had a harvesting machine and made the rounds. Mother and I provided refreshments. Even though growing rice was hard, and I disliked the work, I have never regretted the discipline. At the time, I was just following what my parents said to do, and rice farming was yet another chore; but it taught me something important. You start something and you don't quit. It's the idea of completion. When you begin something you complete it through the entire process, through the many seasons and months. Later I learned this lesson in other ways, or re-learned it all over again.

What was the mood in the country? I don't really know. In the rural countryside, where I spent the war years and after, the hardest thing was the lack of food. The physical devastation and atomic bombs were elsewhere. I had my special circumstances with my father's anger and verbal abuse to always keep at bay. I often felt lonely and isolated. But I was growing up, a teenager, and this kind of mental state was common in my cohort at girl's high school, a very *kodoku* state of mind, a state of solitude and isolation. I wrote poetry on the subject, a time-honored theme for Japanese verse. We were sentimental about a lot of things. I wrote a poem in my diary of 1947, age 17, in Japanese, and translate it as:

My day in state of solitude . . .

I live without any contact
this is my way
of life and am happy . . .

I wait for time, but time is
unkind . . .
I spend my days unintentionally

waiting for the
gleam of light to come . . .
as I look forward to that day with
pleasure.

I kept a diary for much of my time in Japan, but only my diary of 1947 remains, from two years after the war ended. In it I sometimes referred to myself in the third person, as "Bara," the Japanese word for Rose. I don't know why I did that. Rose was my favorite flower, for sure. I loved the color and scent, and velvety texture of the petals. I didn't mind being called Fumiko, a perfectly good Japanese name, but in my diaries I often referred to myself as Rose, especially as I was considering my position as a Nisei, that is, a person born in the US to Japanese immigrant parents. The diary entries aren't always fully coherent; a teenager pouring out her thoughts.

Women planting plugs of rice in Yamaguchi prefecture near my maternal grandfather's house. In summertime the fields were green with the growing crop, very beautiful.

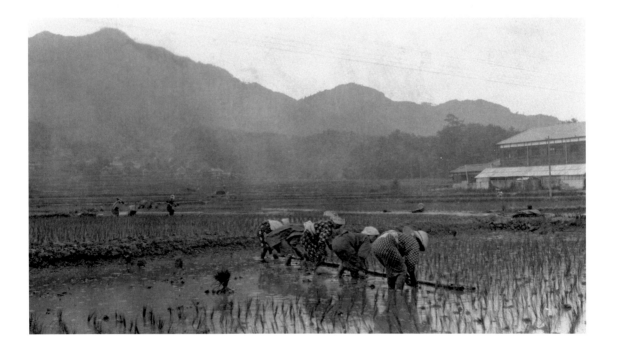

May 4, 1947

weather cloudy becoming fair

Today is Sunday. Somehow I'm very lonely . . . I must be weak [because Miss Ojima felt she had to talk to me]. I don't think so. Or it could be it's my environment, and it bothers me. I wonder why I feel like this. What a lonely life it is. Somehow I learned that society has no compassion. Perhaps I have to get older to understand.

But if I'm home I'm not so depressed. When I'm in school together with others I feel jealous [because I'm not part of a clique]. At home I don't feel lonely. But at school with so many different people, I feel more jealous. I shouldn't feel like this and be more broadminded. But I'm in that situation. I wonder if this is because I'm a Nisei, that is, not quite Japanese. But I'm looking forward to future happiness, so I'm happy. Rose personally has to be more strong-minded. I should live strong, couldn't I do that?

So that I feel strong, I must leave it alone and no use to think about it. Those things come to my mind but I must leave them alone. Why not? I want to live strong . . .

May 5, 1947

Today was middle school 50th anniversary [at the boy's high school]. So half the faculty members [of the girl's school] were not there, helping. 2 hours of freedom, 1 hour of class time. It was English class. We studied [by ourselves] because there was only 1 class meeting. I wanted to borrow a reference book. I'm talking about myself again. It's about "Nisei complex" I have—could be Nisei have two Japanese parents but kids are smart (Japanese parents supposed to be smart). We are proud to be Nisei. The Japanese have their own positive qualities. Nisei. I think they felt envious. [In other words, some students were envious, maybe because of my American Nisei background and because I would be returning to a land of opportunity, but all of us had Japanese parents and so we were all equally smart.]

There was some talk about Nisei among the native people. I wonder why they talk like that? How rude.

Probably second-generation are being discriminated against. That's probably what it is. They are talking about Rose, I suppose. I'm mad. I wonder what they are thinking? I'm fed up with them.

There's another friend I have, Michang, I talked with her about the English class we had. I wonder what she thought about it? I hope she's not angry.

. . . I wonder what they are thinking about Rose?

Gathering of classes [for a contest], and finally I lost. Perhaps it was lack of practice. Another girl in my class, Yochang, cried. Solitude might be a lot more in city people, do you suppose?

In 1947, two years after the war ended, my brother George and I were finally ready to return to America. We had our tickets and passports, and the necessary signatures, all obtained with much effort. To pay for the journey, my parents had borrowed money from my mother's brother, my uncle Shuichi Fukui, who lived in Tacoma (and which I would pay back over the next three years). Before leaving, we took the train and went to see our maternal grandparents in the southern part of the country, to bid them farewell. I didn't know them well and mostly remember that my grandmother was fat and could barely heft herself over the step into the kitchen, where she spent most of her time. She cooked soft rice for us, which I liked.

July 28, 1947

Just returned from Yamaguchi prefecture visiting grandparents and relatives. It's on the waterfront and was cool. I forgot all about the past distress back home and had a very enjoyable time.

What a tragic scene looking from the train window [at the train station]. The large concrete building is totally annihilated and only the skeleton remains that will be difficult to rebuild any time soon, but for now, it is only a sight to show to foreigners. How disheartening.

Though the war ended, the area is filled with black market items. Losing the war, how can all that merchandise be there for such high prices? How can this be? . . . I question the country's economic system and felt envious, and at the same time sadness. With the return of trade missions, we hope the citizens will wake up soon to live by doing the right thing and see the light for the future. This is what we Nisei, second-generation Japanese Americans, wish to "shout."

August 15, 1947

Today there was to be a PTA meeting and a meeting about trade reopening [at the school] and I was very happy to see my father there at the [trade] meeting. I met Ms. Oikawa, a teacher I had known in grade school. Once last year she lent me a local village newspaper

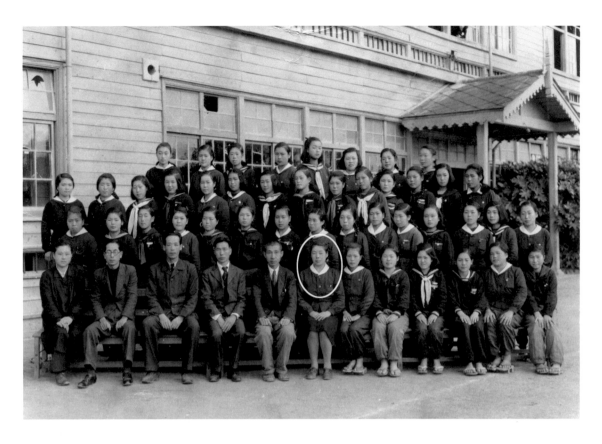

School photo from October 1947, the month I left for the United States. I'm the only student, boy or girl, not in slacks. My father is seated fourth from the left on the bottom row. He never wore a kimono even for special occasions. I never saw one in his closet.

and I had forgotten to return it. She wanted it returned. It was an embarrassing moment. I will return it to her tomorrow.

The environment is unbearable at home [due to Father]. *How can I fill the space to change it to harmony? To attend the school is my best joy and where I feel relaxation. However, today, my father attended meetings and I was never so happy.*

My dear brother, Yoshiharu Shimamoto, how I wish to see you and share my experience about life at school and my impending return to America. [Yoshiharu, my older half brother, was in the Japanese army when the war broke out. He was sent to Manchuria and ended up in prison in the Philippines. He was not released until a year after the war ended. That's when I found out he was alive. He was often in my thoughts as I really adored him.]

Back to USA
1947, AGE 17

After getting all the final paperwork in order and taking photos of my classmates, and many "sayonara, good-byes," my brother George and I were ready to leave. Mother had a special occasion kimono that she had sewed, lavender-colored with a delicate pattern, along with

a matching *haori*, a kind of jacket. She wore that kimono and haori to the bus stop in the tiny countryside town of Takakura outside of Kukuda city. She stood in her kimono as we pulled away. It was the last time I saw her.

Father took us to Yokohama. Mother sent me a telegram saying my half-brother Yoshiharu might come. Oh my gosh, I was excited. I had such affection for him but we rarely saw each other. When he came that morning to see me off, I was so happy. He put his hands on my head, smoothed my hair, and said, "my, how you've grown up." Then we said good-bye, and George and I boarded the *Marine Adler*, a military ship bound for the United States of America. Fusae and Gene stayed in Japan with Mother, attending seventh- and eighth-grade junior high school in Kakuda. I had spent seven years in Japan, my preteen and adolescent years, from ages ten to seventeen, and I was now finally heading home to America.

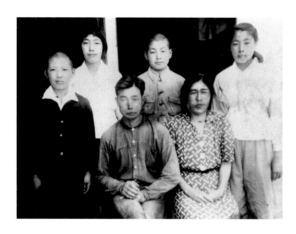

The family gathered before George and I left for the port of Yokohama and a boat to the United States. Standing are the kids, from left, Gene, Fusae, George, and myself. Mr. Ishibashi took the photo.

Boarding the boat at Yokohama harbor were many other children, Americans born to Japanese immigrants, stranded like us in Japan when the war erupted. All ages were present, some accompanied by parents and some just youngsters alone like us. Many immigrant parents had sent their older children to Japan to be educated, which is why they were there when the war started, most of them living with grandparents.

We journeyed over the Pacific Ocean, encountering all the weather one can imagine. I was seasick as we started off due to the wind and rain. The trip was enjoyable once the sea calmed down and I grew accustomed to the ship's moods. I made many friends of similar background who spoke English, as we did not forget the language during the war years. If I needed to use Japanese, the friends understood. We dined together, walked and ran around the deck, and almost forgot about life in Japan as we conversed to get to know each other. This was a comforting time.

After two weeks of ocean journey, we arrived in San Francisco. The bay was foggy and I was not able to see where we were anchoring. The ship inched forward. A tall building appeared out of the fog. Then I knew I had finally arrived back at my motherland called "America." I felt warm inside my heart knowing that I was once again to stand strong on the ground of my birth country.

George and I landed in San Francisco in 1947, returning to our native country without our parents or siblings. Back of the photo says, "Landing day!! Oh happy day!!" I was 17 years old, Geroge was 15.

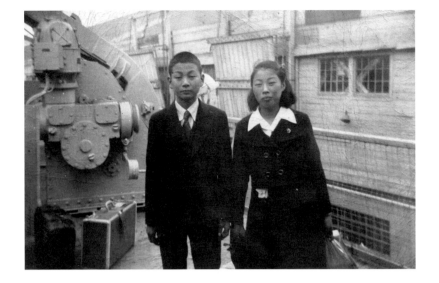

We disembarked and were questioned at immigration. "Why did you go to Japan?" the official asked. "I think we were there to be educated," I said. "You don't have to say such a big reason," she said. I remember that so well. We then went to the train station, bought tickets, and traveled north to meet our relatives.

Tacoma and the McGavicks

1947–1948, AGE 17–18

We arrived at Tacoma's Union Station in the afternoon. Waiting on the platform was our cousin, Miki Fukui, five years older than me. She was the daughter of my uncle Shuichi Fukui, my mother's older brother, who had lent the money to pay for our trip. They and other cousins were living in a tiny rented house after returning from Tule Lake relocation camp in California. They were among the 120,000 West Coast Japanese Americans forced from their homes and businesses and interred during the war years, per Executive Order 9066 from President Franklin Roosevelt.

We were tired from the train ride to an unknown city and the new environment, but being with family gave us a secure feeling. I was glad to reach our final destination and appreciated the help for my brother and me to gain a foothold and start our dream lives in the United States. What a confused situation and mishmash of loyalties for my family during the war. My half-brother serving in the Japanese army. Myself, an American citizen, stranded in Japan as a preteen and adolescent and going to school there. And my relatives in America rounded up from their homes and imprisoned in concentration camps, including my Uncle Fukui who was a soldier in the US military during WWI and

who lost his oldest son during WWII fighting for America at the Battle of Iwo Jima. But family ties are thick and resilient.

Uncle Fukui looked very much like my mother, the same mouth and same self-contained temperament. We stayed at his house for just a short time. Within two weeks, both George and I moved out to American families, taking care of children and doing chores to earn our keep. George of course didn't like it. He left right away for California and made a life for himself there. He was fifteen. I was living with the McGavick family, 17 years old, helping with the household while attending school and getting paid a small amount. Leo McGavick was a lawyer, and he and his wife had three children. I entered tenth grade at Stadium High School. Math, science, and art classes were repeats from Japan, but history and English were difficult. I had to relearn the English language. I studied Latin to better understand the roots. I was also really into sweets, perhaps because of the years of deprivation. Mrs. McGavick suggested I eat jell-o and not so many cookies and cakes, as I was becoming pudgy. I soon returned to my normal skinny self.

In the summer, I stayed with Uncle Fukui and worked at nearby farms picking strawberries and raspberries. We were paid by the flat. I earned $83 for the season's work. There was another young person there, named Sako, only 15 years old, living with his aunt and uncle. He was born in the United States, but like me happened to be in Japan when war was declared and was stranded. He didn't speak much English and had a bad attitude. According to my diary entry of July 14th, I hoped that he could become a better citizen and gave him $25. He was suffering without money, I thought, and I felt that he would change and for that was willing to skip the fun things for a while. Even if I didn't have much, still I did not regret making the gift. That's what I wrote in my diary, which I still kept in Japanese at this time. I was well aware of the weight of financial burdens since I was paying back the loan to my Uncle Fukui. Perhaps I was naïve in believing that Sako would evolve for the better. Another fellow working at the farm, a friend of my brother George, found out about the gift and was angry. I didn't care. I said someday he would understand.

The Hallens
1948, AGE 18

After nearly a year at the McGavick's, I had to find another home. They had hired a fulltime adult nanny over the summer. I advertised in the *Tacoma News Tribune*: "schoolgirl will help with household chores—live in." The next day I received a phone call at my uncle's place. It was a childless couple, the Hallens. She was Mrs. Junia Todd Hallen, daughter

of the second president of the College of Puget Sound. I went to meet her. She had full-body arthritis and was walking around the house on two crutches. Her first question was, "Can you pin curl my hair?"

She had the most beautiful smile with a twinkle in her eyes and gentle laughter. I learned the routine of housework for each day. She wrote everything down so that I would know what to do before school, after school, and for meal preparation. It was all part of learning the Western ways of cleaning and cooking, and she was teaching me language usage as well. Every Saturday when the vacuuming was finished, Mrs. Hallen showed me how to bake cookies, giving me directions from a chair. Soon baking became a Saturday routine. Afternoons, I walked twenty minutes to the ten-cent store to shop for simple household items.

Finishing High School in Tacoma

1949–1950, AGE 19–20

One day, during the second semester of my junior year in high school, Mrs. Hallen (pronounced Hal-len, to rhyme with talon) asked how I was getting along. I showed her my report card. She wondered what I wanted to be. My answer was, "maybe a nurse." She immediately said, "you are not the nurse type. Why a nurse?" I answered, because you can live at the Tacoma General Hospital building, have free room and board while attending classes, and graduate in two or three years. Practical reasons.

"What do you really want to be?" she asked. My answer without hesitation was, "to study and be a chemist and wear a white lab coat." She replied, "You are going to college!"

During this time I was communicating with family in Japan by letter. Mother wrote monthly. My brother Gene and sister Fusae wrote from time to time. I wrote in my diary regularly as well, almost daily, as if having a conversation with my mother, telling her everything I was doing, and especially, "I miss you."

My sister Fusae helped Mother with cooking and chores while she attended junior high school in Japan. She complained about it all the time in her letters to me. She was now the mainstay for household chores, and I understood how she felt. Despite her tuberculosis, Mother pursued making sure Fusae and Gene would return to the United States. She filled out passport applications, talked with the consulate general, and arranged tickets. She was determined. She borrowed money from the American government to pay for the trip. She wanted all the kids to be close to one another. We dreamed we would all be together again and the family reunited.

Meanwhile Mother's cough became worse. She developed one severe cold after another, and basically had a perpetual cough. She had to leave

My graduation photo from Stadium High School in Tacoma in 1950.

the cold northern climate and return back to Yamaguchi prefecture in the southern part of Honshu Island where her parents lived. There was plenty of room for my sister and youngest brother to live there as well, and they went with her. Within a few months, though, her parents died, first her mother, followed by her father.

Another bad thing that happened when Mother went south, as I learned by letter; Father divorced her and remarried. Oh my goodness. Poor Mother, I thought. Two marriages ending in divorce. I felt so bad for her. She deserved better. Father married a Japanese woman who had a child, and later they had another child together.

Soon thereafter, my mother's hope against hope of seeing all her children arrive and succeed in the United States was over, as she passed away in May of 1950. She was fifty-four. I had just graduated from Stadium High School. My deepest regret is that I did not get to hold her hand and thank her for all she'd done for me, and say good-bye.

I will never forget how Mother was so encouraging to me all the years we were apart. She wrote me letters: "Do the best you can . . . make a good life in the States. You can do it and be happy." When at times I became discouraged, I sensed a gentle tap on my shoulder and heard her voice. "You can do it . . ." I would turn around, but no one was there.

Mother knew she was going to die. At least I assume she knew it. But she had arranged for the remaining two kids to go to the United States. Mother was assured that we would all four be together. That no doubt was a consolation for her. Father had agreed. It was out of his hands.

My siblings Fusae and Gene took the boat and arrived in Tacoma in August, just three months after Mother passed. They came to the Hallens' house. There was an extra bedroom and the Hallens were generous. Mrs. Hallen had many connections and friends, and within a short time my siblings went to nearby homes to be schoolboy and schoolgirl, watching children and doing household chores. Fusae didn't like taking care of kids, and Mrs. Hallen found her another place without children. Gene very quickly left and went to California and met up with George.

I graduated high school and entered the College of Puget Sound in 1950. That was partially my mother's doing as well. She knew I wanted to study beyond high school, but some of my cousins in Tacoma were insisting I should get a job after high school graduation. The memory of internment camp was fresh in their minds, and everyone was struggling with tough challenges, not least being of Japanese heritage in post-war America. They wanted me to become a secretary or something and start earning money. But my mother had written to my uncle Shuichi Fukui, her brother, pleading to let me attend college so I could continue with

my education. My uncle told me she had written. He said to me, "Why not? It's your life, do what you really want to do."

The Hallens and College

1950–1951, AGE 20–21

I began classes at College of Puget Sound. The Hallens lived within easy walking distance of campus in a three-bedroom house, very convenient. Mrs. Hallen's profession was to review and lecture about books for groups of ladies who regularly came to the house. One of my jobs was to set up chairs and make flower arrangements for the guests. I enjoyed arranging the flowers in the living room. Mrs. Hallen was working on a PhD in philosophy when she developed the arthritis that prevented her from continuing. Now she read book after book from best sellers to environmental tomes, and the ladies often had wonderful laughing moments.

In 1951, Mrs. Hallen's father, Dr. Edward H. Todd, the visionary past president of the college, passed away and I attended his memorial sitting between Mr. and Mrs. Hallen. The following year, her mother, Florence Todd, passed away. I again sat between the Hallens. But at this service, Mrs. Hallen's sister-in-law grabbed me by my shoulders and marched me to the end of the bench. Mr. Hallen was mad that she treated me like that. I didn't know I was being discriminated against. Mr. Hallen restored me to my seat. They really watched over me and took care of me like their own child.

I had other brushes with discrimination, though I didn't think of them as such at the time. In high school a girl pushed me into the pool during the mandatory swimming class; I couldn't swim and was sinking, gulping water and really drowning, till another student pulled me to safety. The time I was asked, in the service group for honors students to which I belonged, to not participate at an event, Mrs. Hallen got that look in her eye and said, "you are going," and made sure I went. I didn't think it was prejudice; I just thought there were bad people.

Resentment and discrimination take many forms. In Japan, I had felt frictions with my native Japanese classmates, as I was American and a Nisei; and after the war, I was going back to America and they were not. Back home in America, people of Japanese heritage were also subtly discriminatory. I was a Kibei, a Japanese American who had been educated in Japan and then returned to the United States. The Japanese have words for all these different groups: Issei, first-generation Japanese immigrants; Nisei, second-generation children born to Issei; and, less familiar, Kibei, literally "go home to America," a term popular in the 1940s and '50s for Japanese Americans born in the United States who received their

education in Japan and then returned. I never felt comfortable with the Nisei in Tacoma, even though I attended church with them and belonged to a singing group. Nisei were Nisei. Kibei were Kibei. I felt ostracized. I was not invited to social events. One time, talking about the cold shoulder I was experiencing, my uncle told me that Kibei had extra Japanese culture behind them, so there was a cultural difference between Kibei and Nisei. Maybe some Kibei didn't have as much English, either. At any rate, most of my friends were my college classmates.

In this environment, and with support from the Hallens, I continued at college. Learning English was much smoother due to Mrs. Hallen's tutelage. I had difficulties especially with courses requiring specialized language like psychology and religion. Mrs. Hallen would read along with me, explaining and writing down the meaning in short sentences. I was helped as well by the professors who knew I was struggling. In my major of chemistry, I enjoyed biochemistry, environmental studies, and applied organic chemistry. Besides chemistry, I took painting as an elective and painted on my own schedule in an empty room where I stored an easel. Professor Francis Chubb, an art historian, was my advisor. She would come by and give me pointers. I continued to write in my diary almost daily, now writing in English. Although my mother had passed away in May of 1950, right after my high school graduation, I continued conversing with her in my diaries for many years as I worked at the Hallens and attended college.

DIARY (age 20)

Tuesday November 28th, 1950
Weather: fair

School went very good. I had enough sleep last night, that's why I [was able to] concentrate on lecture in chemistry. Wrote to George and even studied 2 hours at the library. Wasn't sleepy at all. Studied 2 hours at home but shall go to bed today 10 p.m.

Shig Miyata called to make a date with his friend and Nancy. I shall do that on Thursday. I don't quite understand these boys. Worked hard today.

Goodnight, Mother

Wednesday November 29th
Weather: cloudy

Chem went really well. Lab took whole 3 hours, did titration. Lots of fun. Quiz went OK too.

Harry [cousin from Hawaii who was going to school at University of Washington] *wrote to me. His letter was decent and quite formal in the way it is written. I'm answering tomorrow since he asked to see a copy of my answers to math questions* [he was helping me with calculus]. *Called Fusae. She's doing OK. Spoke to Katsuji Abe* [a friend in chemistry class]. *He's doing OK.*

Goodnight, Mother

Living and working at the Hallens wasn't always easy. Mrs. Hallen often complained about her arthritis. She could be irritable and find little faults. "This shelf isn't well dusted!" "The bed spread isn't smoothed!" One time she was especially virulent. I couldn't take it any longer and said, "Do you want to find another helper? Maybe I should leave here . . . ?"

Mr. Hallen had his head down. I knew he was worried I would go. We all finally calmed down, and after this, life became better as I learned to ignore her complaints. I almost felt the pain in her crooked fingers. I thought, "it's not me, it's her, and she's frustrated on crutches, and suffering." Following that realization, I didn't have a problem. I was strong. I understood Mrs. Hallen. But after me, many helpers came and went. I was proud of myself for sticking it out. I learned to be tolerant of others, especially when limited by disabilities or pain.

It was at the Hallens as well that I learned how to prepare an American-style Thanksgiving dinner. In 1950 Mrs. Hallen had invited her mother and father, the retired president, for the traditional feast. Of course she couldn't prepare it. She directed me from her chair. It was all new to me, and I struggled with the meal preparation, toasting the bread for the dressing and finally getting the turkey going. All those steps. "Stay with it, don't give up," I said to myself. I cherished the experience because I learned how to prepare the meal from beginning to end. And it was like the lesson from the rice fields all over again, sticking with the process through all the steps, compressed into one day.

For the last two years of college, the Hallens paid my tuition each second semester. Christmas morning, on the tree I decorated, I would find an envelope with the tuition check. I always insisted I could not take the check. I didn't know how I would repay them. I said I would attend a fifth year of college to finish; I was saving from what they paid me and would have enough for the tuition if school were spread out over more years. Or I could pay it back when working after graduating. Mrs. Hallen said, "you do not need to return the money to us, but give to others when there is a chance later on."

Many times now people want to pay me back for something or other, but I say, no, I want to make the gift. I appreciate the opportunity to help others, to pay back and pass along what was so graciously given to me. I still volunteer teach at retirement homes and schools, and otherwise quietly contribute to individuals, including financially. That's my natural inclination, perhaps, but the goodwill and gifts the Hallens bestowed on me urge me on. Truly I think about the Hallens often, and the five and half years I spent with them. Their kindness and generosity still guide my thoughts and choices.

Finishing College, Marriage and Work

1951–1972, AGE 21–42

I met my husband, Yoshikiyo (Yosh) Kimura while attending the College of Puget Sound. Our paths crossed often as he was a chemistry major like me, though two years ahead. He was a WWII veteran attending college after his discharge. He'd been in the US army when war broke out, sent to Japanese language school to learn interrogation techniques, and then sent to Japan when the war ended.

In that era there was no intermarriage. Japanese people married Japanese. His family was desperate that I should marry him because he was getting so old. He was twenty-seven and an only child. I was in my early twenties when we first met. We had a date to go to the movies. I was a junior. We became engaged. How would I go to college if I were married, I wondered? I wanted to finish college. Finish what I started. Get my degree. Everyone wanted us to get married before my college was finished. There was a lot of pressure. I said no. Yosh wasn't happy and said we should break off our engagement. So I returned the ring. I was determined to finish school. He was scared and very upset.

Then a few months later we got back together. By that time I was in my senior year. Graduation wasn't so far off. I wanted to finish school, but I also wanted to get married and have a family. I really wanted children. I didn't know if I could have a family because of my accident with the kerosene stove and the skin grafts. Mrs. Hallen let me go to California to visit a cousin. While there I went to see the doctor who had taken care of me at the hospital some fifteen years previously. "Of course you can have a family. Even if the skin does not expand, hormones can take care of it." Then I was gung ho about getting married.

During the seven years I was in Japan I rarely talked with my father, having only minimal interactions and keeping him at bay in my mind. After returning to the United States, I never wrote to him and he never wrote to me. But by the time of my engagement he was a leader in his village and came to California on a special program to learn American

Circa 1953, while at college studying chemistry.

farming techniques. He wanted to visit relatives and myself, and arrived in Tacoma. I still didn't talk to him! It was a real block. Yosh's father asked me, why? Of course, he didn't know about my scars and my father's verbal abuse, and I didn't want to reveal these things to him or others. But I couldn't talk with Father. I just couldn't. My tongue froze and the words wouldn't leave my mouth. There was such a complicated well of anger, resentment, and habitual silence about his treatment of me and also of Mother. Why couldn't I tell my father how I felt? In Japanese culture, you don't do that. You don't talk back. Or maybe I lacked the mental strength or maturity even though I was twenty-four years old.

Father returned to Japan. Within a year, a motorcyclist, apparently inebriated, struck him while he was walking home from a village meeting. He passed away shortly thereafter. As many as four hundred people attended his funeral, according to my brother George who received a letter from our stepmother. Father had become a well-regarded figure. I didn't have a strong feeling one way or another about his death, but I knew his public and private faces were different, at least to me.

I graduated college in 1954 with a Bachelor of Science degree in Chemistry with honors, having attended college for four years including three years of summer school.

Yosh and I married a few months after graduation on September 25th in the Gail Jane Memorial Chapel at the College of Puget Sound, with Dr. Phillips, a religion professor, officiating. I sewed my own wedding dress, using what Mother had taught me. I couldn't afford a new dress at any rate. I found a pattern and made the dress over the summer at the Hallens; she had a sewing machine upstairs. It was made of a cream-colored taffeta-like material, and I wore it with white flats and a veil. Yosh's parents were very happy because he was getting settled, their one child moving on with his life.

I didn't tell Yosh about my scars and the burn accident till after we were engaged. He didn't say much or ask any questions. Yosh finally saw my scars on our honeymoon. He said, "It's only skin deep," and soothed my skin. I was happier than ever.

Yosh was working at a private laboratory concerned with food safety. I became employed as a senior laboratory technician at Western Washington Experimental Station in Puyallup, part of Washington State College. My job was to understand the digestibility of cow feed by analyzing samples of powdered feces. My curiosity led me to develop more effective laboratory procedures that were also much cheaper. Vern Miller, my supervisor, was a patient scientist who encouraged younger employees to succeed. Together we wrote up the development, myself

as lead author, for publication in *Journal of Agriculture and Food Chemistry*, in 1956. My husband Yosh helped me prepare and edit the paper, and subsequent ones.

Four years after my marriage saw the birth of twin boys in November 1958. I was almost thirty. It was a hard pregnancy. I couldn't walk well and had a lot of pain and cramps. We didn't know I had twins. They were born prematurely at 7 months. The doctor was surprised: Out came one child and then another. Richard and Raymond. I can laugh now, but at the time it was a lot of stress and expense. Rich weighed 4.1 pounds and Raymond 2.14 pounds. Ray was in the hospital for five weeks before coming home after achieving a weight of five pounds.

A year later I had another boy, Howard, and then eight years later my daughter Jeanne. "Was I a mistake?" Jeanne asked me once. "No," I said. "We waited every year for a girl, and after eight years, it was a gift."

As the children were born I stopped working and stayed home. Home was a small house Yosh and I had bought when I was first pregnant, in a suburban subdivision carved from Tacoma's tall Doug-fir trees. Yosh used to carry around all three sons when small. We really enjoyed having them around. He sometimes suggested taking the kids mushroom hunting, or to coastal beaches for razor clamming, which we did; it kept me busy with excursion logistics.

When the children grew older and started school, I started working again. I was employed part-time as a biochemist at the biology department of College of Puget Sound. The project was to identify field mice from Oregon and Washington. The live samples came and I analyzed their blood to determine species. We also drew and analyzed the blood of native and non-native seagulls. I wrote a paper on our findings as lead author, published in *Science* magazine in 1970. This project was funded by the National Science Foundation and headed by Dr. Murray Johnson, a Tacoma physician who enjoyed being outdoors and capturing the squawking, squealing samples. For four years, this project nurtured one student each year working towards a master's degree. I worked with the students in the laboratory;

My first scientific paper published in *Journal of Agricultural and Food Chemistry* in 1956.

CHROMIC OXIDE MEASUREMENT

Improved Determination of Chromic Oxide in Cow Feed and Feces

FUMIKO T. KIMURA and V. L. MILLER
Western Washington Experiment Station, State College of Washington, Puyallup, Wash.

Chromic oxide is widely used as a reference substance in nutrition investigations of domestic animals. An analytical method that is simple, specific, rapid, and requires only common laboratory equipment, may be used to determine chromic oxide in feeds and feces in the amounts commonly used in digestibility experiments with dairy cattle.

Chromic oxide (Cr_2O_3) is widely used as a reference substance for studies of digestibility of domestic animal feed and forage. Kane, Jacobson, and Moore (4) described a volumetric method modified from that of Edin, Kihlen, and Nordfeldt (3), using sodium peroxide fusion for the oxidation of the chromic oxide to dichromate. However, these methods are tedious. Bolin, King, and Klosterman (1) reported a colorimetric method using sulfuric-perchloric acid mixture with molybdate catalyst as oxidant. Low results may be obtained with this mixture with excessive heating, because the formation of hydrogen peroxide reduces the hexavalent chromium (5). However, Day (2) reported that this difficulty may be overcome by carefully controlled time, temperature, and acidity.

A colorimetric method is described, which uses a nitric-perchloric acid oxidation with molybdate catalyst. Time, temperature and acidity are not critical. This method requires only common laboratory equipment and eliminates the need for constant attention (2).

Experimental

All reagents used meet ACS specifications.

Analytical Procedure. Transfer a 1-gram sample containing 3 to 7 mg. of chromic oxide to a 100-ml. borosilicate glass volumetric flask. Add 1 to 5 mg. of sodium molybdate and 10 ml. of nitric acid. Boil gently on a hot plate until the acid is about half gone but not less than 10 minutes. Remove the flask, cool slightly, and add 3 ml. of 70% perchloric acid. Boil with stronger heat, mixing well to complete oxidation in 10 to 15 minutes, and continue heating for 2 to 3 minutes. Remove the flask from the hot plate. Allow to cool to room temperature and make up to volume with water. Centrifuge, or let stand to allow silica to settle.

Compare the sample solution with a standard curve prepared from known amounts of potassium dichromate solution of approximately the same acidity as the sample, to give a range of 10 to 80 γ of chromic oxide per ml. Determine the percentage transmittance in an Evelyn photoelectric colorimeter using the 440-mμ filter.

Discussion

One-gram samples of feces containing approximately 6, 13, and 19 mg. of chromic oxide were oxidized with 5, 5, and 7 ml. of perchloric acid. The use of 7 ml. of acid offered no advantages over 5 ml., but when 3 ml. was used the resultant solution was too viscous.

Different portions of the same sample were oxidized, using the described method, and the effect of time of digestion was observed. The data recorded in Table I show that heating for 15 or 20 minutes after the completion of oxidation had no detrimental effect. Rapid cooling and dilution as reported by Day (2) were not necessary.

Table II shows the recovery of known amounts of chromic oxide in the range of 3 to 38 mg. The standard deviation is ±0.018 mg. in the range of 0.3 to 0.8% chromic oxide, most frequently encountered in digestion experiments.

Acknowledgment

The authors acknowledge the aid of F. R. Murdock, associate dairy scientist, Western Washington Experiment Station, in this investigation.

Literature Cited

(1) Bolin, D. W., King, R. P., Klosterman, E. W., *Science* **116**, 634 (1952).
(2) Day, K. M., *Ibid.*, **120**, 717–18 (1954).
(3) Edin, H., Kihlen, G., Nordfeldt, S., *Lantbrukshögskol. Hüsdjursförsöksanstalt* **12**, 166–71 (1944).
(4) Kane, E. A., Jacobson, W. C., Moore, L. A., *J. Nutrition* **41**, 583–96 (1950).
(5) Smith, G. F., "Mixed Perchloric, Sulfuric, and Phosphoric Acids and Their Applications in Analysis," 1st ed., G. Frederick Smith Chemical Co., Columbus, Ohio, 1935.

Received for review August 4, 1956. Accepted October 27, 1956. Approved by the Washington Agricultural Experiment Stations for publication Project No. 1172.

Table I. Effect of Extra Heating on Recovery of Chromic Oxide

Heating Time, Min.	Chromic Oxide Present, Mg.	Chromic Oxide Found, Mg.	
2	6.27	13.0	18.9
5	6.27	13.1	19.0
10	6.22	13.0	19.0
15	6.22	13.0	18.9
20		13.0	19.0

Table II. Accuracy of Method

	Chromic Oxide	
Weighed, mg.	Found, mg.	Recovered, %
3.30	3.29	99.7
5.95	5.90	99.2
5.25	5.21	99.2
6.40	6.40	100.0
7.95	7.92	99.6
10.1	10.1	100.0
10.7	10.6	99.1
14.4	14.3	99.3
15.1	14.8	98.0
15.1	15.1	100.0
26.9	27.0	100.4
38.4	38.4	100.0

they learned to draw blood and became familiar with lab procedures, and wrote their dissertation papers.

Becoming an Artist

I had always enjoyed doing artwork, and had made watercolor and ink paintings while a schoolgirl in Japan, and later, while in high school and working for the Hallens, I made drawings, for example, of a woman in a colorful kimono. Throughout my years in college, even while pursuing a demanding major in chemistry, I found time for painting and watercolors. After college and marriage, though I loved working as a biochemist, I started painting landscapes after family trips to the mountains and ocean. I saw the scenery, and it was so beautiful. Of course, many people get powerful feelings from nature, and not everyone makes watercolors and paintings. But that was my response. I painted at night in the kitchen when everyone was asleep, and found relaxation and stimulation in the beauty of nature.

I remember painting a single iris in a vase, the petals so delicate, trying to reproduce that appealing softness using watercolor. I painted the trees of Point Defiance park, Mount Rainier, coastal scenes, and urban landscapes. I worked in a variety of representational styles and was influenced by the American modernist John Marin, who embraced angular forms and abstraction as well as bright colors.

I was fortunate as my artworks started to sell. Without a lot of effort I received commissions. Unexpectedly, my friend Grace Fredricks, who was in charge of exhibits at Washington State History Museum, suggested I exhibit in the top floor gallery. This was my first solo exhibit, in 1961, and featured Western-style watercolors.

Around this time I was also painting small works of different subjects such as butterflies, fruits, and trees, and using different mediums such as watercolor, collage, and sumi ink (*sumi* is the Japanese word for ink; *sumi-e* is Japanese ink painting, typically done with a brush). These were explorations of what was possible.

One day I was painting matsutake mushrooms, the fragrant pine mushroom found in Washington's forests, but was frustrated. I was using watercolor in a Western representational manner, but my efforts didn't seem successful. I didn't want to make outlines and fill in, and didn't want to do the usual watercolor lights and darks. I thought of sumi-e, and the methods of Japanese brush and ink painting which I had been exposed to in Japan. I wanted to do one brushstroke for the mushroom cap with three-color ink, that is, loading the brush with light, medium and dark ink so that one stroke would leave multiple shades.

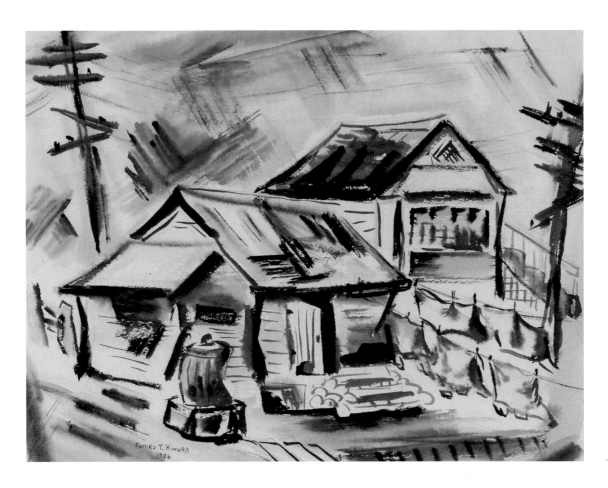

WabiSabi, 1956, watercolor on paper, 14 × 18 inches. A watercolor from when I was twenty-seven and recently married. The scene depicts a crooked, beat-up garbage can and a shed. The house behind was where my husband's parents lived. The shed was rented by another family.

But it was a struggle. I had no practice. Nonetheless, I tried, and to my surprise those few spare brushstrokes seemed to capture the essence of the mushroom and the image was somehow more realistic. This was my first sumi painting experience as an adult and I thought, "This is it. A different way of working. Spontaneous. Simple. Capturing the essence."

I was soon invited to exhibit small paintings at the Handforth Gallery in the Tacoma Public Library. I took the opportunity to begin studying the history and methods of Chinese painting, which were so influential on Japanese art.

Although I had used the Asian brush for calligraphy and art during my seven years in Japan, a regular course of study for young students, I had not practiced or thought about it for nearly thirty years. How was I going to learn sumi-e as an adult? I was stymied. Then one day I happened to see in the *TV Guide* a program titled, "Japanese Brush Painting." It was an instructional show on public television with Mr. Takahiko Mikami, an artist and founder of the Japanese Art Center in San Francisco. Yosh came home from work around 5:30, dinner was

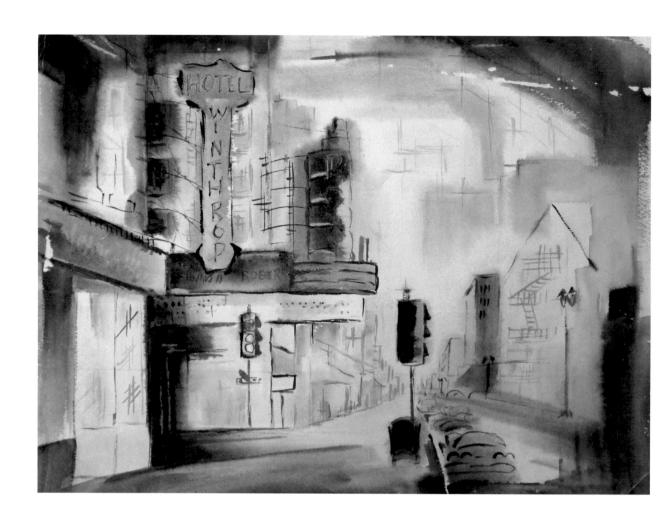

Broadway Scene, circa 1970,
watercolor on paper, 14 ×
18 inches. Painted with a wet-
on-wet watercolor technique
popular at the time.

ready, but I didn't eat with the family. I was on the floor doing sumi! A real teacher right in front of me on the flickering black-and-white screen. I was amazed. I learned about brushstrokes and other things. "Oh, that's the foundation." I felt like I was in a dream. I fell in love with the colors of sumi, the rich blacks dark as night, the thousand shades of gray full of suggestion, and the dance of the brush across the paper.

It was always a juggling act at home. I made dinner, the family ate, and I was on the floor with my simple tools in front of the television. With this beginning and with books ordered from friends in Japan, I continued to learn. Dr. Johnson's funding for mice and seagull research concluded around 1972. I could have found another part-time job and pursued lab work, but I wanted to paint. I remembered seeing a valley near Route 7 with Mount Rainier right there. It was so stirring. I said to myself, "Oh my gosh. I must do this. I must paint. I want to say something with color and brush." I decided to end my career in the sciences to pursue my passion for making artworks. It was a natural turning point.

Teaching Sumi and Back to School
1972–1977, AGE 42–47

As I closed the chapter of working as a scientist in my early 40s, I began teaching sumi painting in local venues. Ever since I had shown at the Handforth Gallery in the Tacoma Public Library I had been asked to teach. I taught at the YWCA, churches, Tacoma Community College, and in Seattle at Uwajimaya, the Japanese food store. There was a lot of interest and the classes were always full. These opportunities gave me reassurance about quitting lab work.

During this time, besides typical sumi subjects from the natural world, I also painted abstract works and made collages using mixed-media materials including gold leaf. The inspiration for one collage series came from my experience in Japan as my brother George and I traveled to say goodbye to our maternal grandparents before catching the boat to America. We saw a train station that had been annihilated during WWII. This was the Ueno train station near Tokyo. There was almost nothing remaining, just a skeletal structure and small children begging for food on an expanse of concrete. It was an apocalyptic scene. I was shocked and the sight implanted on my memory.

I came to understand it would be rebuilt some day as a better train station. The artworks I had in mind needed to include the idea of reconstruction as well as destruction, of cities coming back and people getting healthier, all in a completely abstract way. I made collages by tearing up different papers, mostly green and blue colors, and building up surfaces with them and gold leaf. Gold was symbolic in my mind of rebuilding

Waterfall, mid-1970s, collage, 6.5 × 5.5 inches. One of my first gold leaf collages. Part of the "Reconstruction" series, based on ideas of alchemy: the passage of base materials to gold, that is, the idea of things changing and transforming into something better.

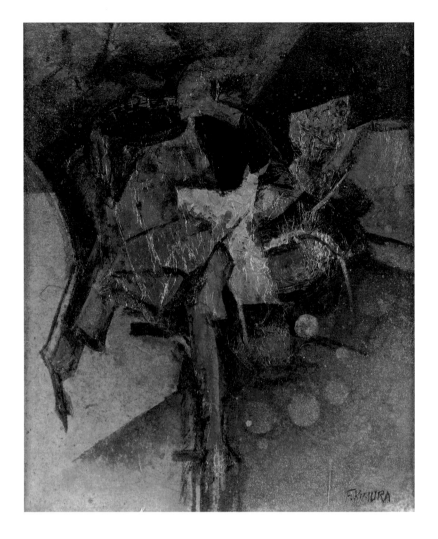

the train station as well as a formal element. I came to gold leaf from the ideas of alchemy, in which the end product of both physical and philosophical transformation is gold, a substance pure, unchanging and noble. With my chemistry background I could well appreciate the notion of complexity transmuted into constituent simplicities and purity of form.

Soon I was feeling inadequate about art and the creative process, not having taken many such studies in college. There was so much to learn. I wanted to go back to school. Yosh meantime had lost his supervisory job at the experimental station in Puyallup when the chemistry department closed. He was unable to find another position and took early retirement at a low income. Financially it was a strain. He was depressed much of the time. He didn't have much interest in activities like church, sports, or PTA, and we already didn't have much to talk about except the kids. He didn't want me to pursue a graduate degree in the arts. I went ahead and

did it anyway. I told him, don't worry, I will earn my own tuition, and help support the family and send the kids to college. I applied and was accepted to my alma mater, now called the University of Puget Sound, and returned in 1975 at age forty-five for a masters degree in art education. That was the only arts degree they offered at the time. I took all the fine art classes available: drawing, printmaking, and painting. One day, Professor Bob Vogel spent an hour in his office showing me various ways of drawing landscapes with buildings. It was a revelation. He wanted me to experiment more. "You have done the same technique for years, you need to try other ways." Professor Vogel helped to open my eyes. He took the time to show me. I felt such freedom to try new methods and materials.

Another important teacher was Bill Colby, who taught printmaking. He never judged my work and made sure I understood that the aesthetic choices were up to me, but he'd say, "You could have finished this two weeks ago." That was really another way for me to be pushed to learn. Monte Morrison emphasized nonobjective abstract painting with no reference to nature. I remember asking him about a shape in my painting that looked like Mount Rainier. He said that was not good, use only a triangle!

From these teachers I learned many things. I learned to experiment more and employ good habits of craftsmanship—no smears on the printing paper and clean miters when cutting stretcher bars and frames. I learned Western approaches to style and form, to compose in an abstract manner, and felt liberated to paint and be creative on my own terms. I embraced teaching and painting professionally. Did I ever miss or feel like going back to lab work? No. I had had three papers published and was satisfied with that phase of my life. I never wanted to go back. And, in a funny way, my process of art making paralleled my work in science, both involving research, experimentation, and development, and appreciating the magic and mystery of the world. So the transition was easy.

Teacher and Artist
1977–1985, AGE 47–55

After graduation with a Masters of Art Education in 1977 with honors, I was employed as an adjunct member of faculty in the University of Puget Sound art department. I taught K-12 art teachers basic drawing methods for twelve years, until that program was discontinued in favor of one about managing social problems such as bullying and discrimination. I also taught at Bremerton Community College for two years, substituting for faculty on sabbatical leaves; I taught figure drawing and

painting to freshmen as well as adults attending after work. Recently an older gentleman who I had taught called out to me by name from a bench at a Fred Meyer store. He said, "You taught us a different way to do art work that gave us confidence as well as knowledge. You should write a book on that method." It might have been an unorthodox method of teaching, but when students were unsure of their artwork, I would say: "There is no right or wrong, there is no mistake in your work, as long as you take some liberty to express from your heart."

I also taught a watercolor and sumi class for two years at Steilacoom Community College as a member of the faculty. I preferred being part-time all these years as I felt I was needed at home when the children returned from school. Some years ago one of my sons said to me, "You were always there when we came home from school and I liked that." This compliment I will always remember. It was worth the struggle of being a teacher and artist, and mother, at the same time.

Finding a balance, though, was never easy. The transition from scientist to artist was challenging. I could sell artworks and did both traditional and experimental works, but I wasn't working fulltime as an artist. Everything was part-time, first as a chemist after children, then as an artist and teacher, and even as a mother—sometimes I had night classes and couldn't be there when the kids returned from school. It was frustrating. But I was able to make ends meet and help support the kids and pay tuitions as they went off to college.

My studio at this time was in Ray's bedroom in our home. I had a folding table and took it down when he came back from college. My art supplies were minimal, a water container and a palette, a set of watercolors, and some watercolor brushes, so it wasn't hard to do. I was teaching, painting, and earning needed money.

Clients came to our home and Yosh was unhappy about that. People had to walk through the living room and past him to get to my studio. Yosh was a solid man, but he was mechanical in his ways, hard-headed and not open to new ideas. As my career progressed, Yosh and I had a fight about all the people coming in and out of the house. A huge argument. I finally said, "You want me to stop painting and not earn any more? Okay, I'll quit making art." He said, "no, don't do that." And he made no complaints after that. But I never knew what he was thinking. We didn't talk much. Maybe he realized that's what I needed to do, or that we needed the income.

Being a teacher is a family heritage, as it happens. My maternal great-grandfather served as samurai to a feudal lord who controlled the Yamaguchi prefecture in 1868 and played a role in the Meiji Restoration.

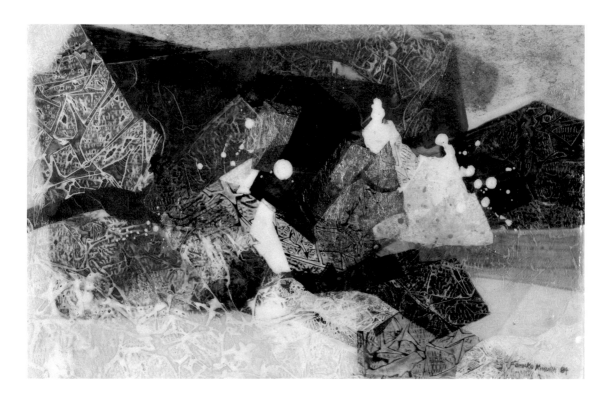

Untitled, 1984, mixed media including gold leaf on acrylic sheets, 10 × 16 inches

All the samurai were ordered to the countryside to implement new farming methods. But my great-grandfather instead opened a *terakoya*, a small temple, to teach the village children reading and writing. My mother had finally realized her teaching dream becoming an instructor of sewing to young girls during WWII, and even my father was a teacher briefly after the war to Japanese middle-school students learning English. My brother George taught Japanese language at UCLA after receiving his masters degree. He also established a karate school in Los Angeles, published two books, one on beauty and the other on prepositions in the Japanese language, and ultimately received an honorary doctorate of philosophy. So teaching is a family tradition and important to me. I love teaching and always learn a lot from my students.

At this time when I was teaching and making art I was also intellectually engaged with books about art, creativity and psychology. I was hungry for all those new ideas. I read books by Arthur Koestler and *The Crack in the Cosmic Egg* by Joseph Pearce, about the nature of reality and using imagination to move beyond the prescribed. I went to lectures. I maintained a friendship with Monte Morrison, my college professor and now colleague, and he suggested books to read which we talked about, and also we discussed art exhibits. It enriched my life so much to know him. There was a new minister at my church, the Rev. Robert Yamashita,

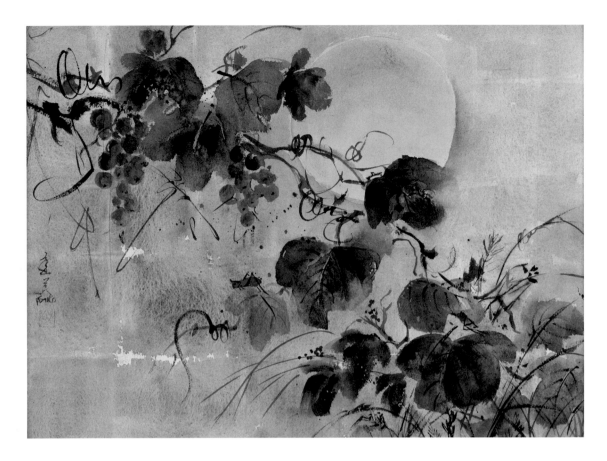

Grapes in Autumn, diptych, mid-1980s to early 1990s, watercolor and ink on paper, 12.5 × 36 inches. My autumn scenes are typically busy with small animals and ripe fruit. I've made them throughout my career, and especially in the 1970s and '80s.

and he was gung ho about intellectual matters, and we read Kierkegaard and other existentialists.

I was also reading Paul Klee's diary. He was an artist that I admired. In my diary at this time, March 8, 1979, I wrote: "Been reading Paul Klee's diary. Feels like I found a friend. But my how he travels a lot to gain ideas and inspiration. . . Paul Klee's statement on color: 'I don't have to pursue it. Color leads me'—I think this statement is great."

I've kept diaries periodically. I had a diary for much of the time while living in Japan as a young girl through adolescence, 1940–47. Only the one from 1947 remains, a dilapidated stitched booklet written in Japanese on thin paper. I continued with diaries after returning to the United States, first in Japanese and then in English, through high school and college. I wanted to let Mother know how the day went. I made lists of everything that happened as if having a conversation with her. I always ended those entries with, "Take care, mom. Miss you," or "Goodnight Mother." I also conversed with my half-brother, Yoshiharu, concluding, "Miss you and praying that you and your family stay well." It was routine to write in the diary before going to bed. I missed my mom

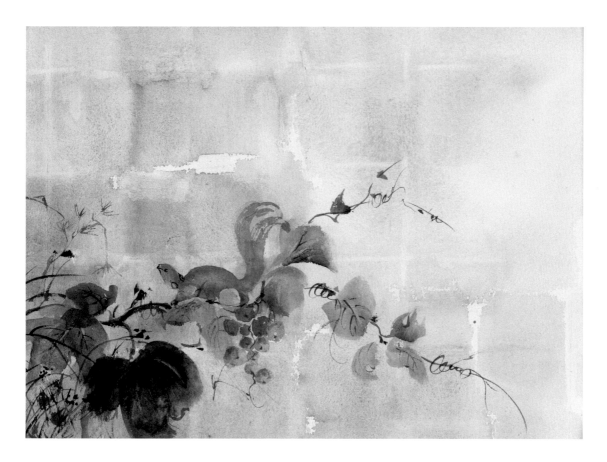

and half-brother and was sometimes lonely at the Hallens. These diaries were small books with hard black covers. After college and marriage, I kept diaries although more intermittently, writing down thoughts on art as well as personal reflections, and also in later years kept art journals in spiral notebooks that were a mix of thoughts, drawings and ideas for paintings.

DIARY (age 49, two years after graduation with masters degree in art education)

March 8, 1979

First warm spring day this year. My blood is boiling after 15-minutes of brisk walk to school with Jeanne. 9:00 a.m. Vacuum the living room for myself and outsiders.

Painted from 9–12, three hours without interruptions. Painted five watercolors of oriental kind that people in general like: persimmons, pine, chestnuts, grapes and rhody. Commissioned by frame shop. Kept five paintings in process and finished as each one dried.

August 8, 1979

So at peace with myself. A trip to Japan was made July 12–28 [with daughter Jeanne, sister Fusae, and Fusae's daughter Ruth]. What an exciting trip with no snags. Had a magnificent time in Fukushima-ken at Takeda's [the father of my brother Gene's wife]. Dr. Takeda is a gentleman through and through. Feels almost as a father. He sliced two peaches for me to taste and eat as he cut them in his hands. A real meeting and sharing of minds. He liked the fuchsia painting very much. He bought it for $1,000, which paid my expenses in Japan. Gave them also the gold leaf [one] all framed . . . All in all, should have brought more paintings to show the galleries and share with more people.

32 years after, haven't forgotten my house I grew up in . . . Tohoku [northeast region of Honshu Island] seemed good, just as I left 32 years ago. Scenery looked lush green, bamboo growing wildly everywhere. House has been remodeled and only stepmother lives there, but she seems healthy and capable. Will be least of my worries. How can I relate all these experiences in artwork? Perhaps it'll take time.

. . . Visited art teachers. Saw Ishibashi [fourth grade teacher] now 82 years old, teaching calligraphy. He recognized me. Onuma too recognized me immediately. Saw her paintings, she's still doing oil paintings, semi-abstract as she used to, but the colors and technique give that certain glow that is really beautiful . . . Ashina, was so nice to meet him once again after 32 years. He was so instrumental for my growth in becoming a scientist. Once upon a time he got me interested in chemistry.

. . . Tradition keeps me in tune with life grounded as one with nature, man and myself. Everyone there [in Sendai] seems to be living in harmony with nature. They seem to be accepting and taking pride in tradition and making the most of it.

Bought quite a few art supplies in Kyoto. Brushes, paper, colors. It was a fun time of life buying supplies one cannot find in the U.S. . . .

November 2, 1979

After [many guests this] summer, was back on routine for preparation of the exhibition in October . . . More than 100 attended the opening . . . I feel really good inside and believe that's what comes out . . . am really anxious to begin my new canvas works as well as splash spontaneous works. I must paint the realistic kinds for support of my supplies and expenses but must balance with real creative paintings also . . . I am very fortunate to have this lot in life—family intact, Yosh a good friend, husband, and a man—boys are all pursuing within their

limits at University and Jeanne is doing better at school. There are many friends I can relate to—pray everyday in gratitude.

The classes are great. 20 in painting class, 32 in sumi-e class . . . Students are my source of inspiration as well as what I perceive in nature.

I may not be a pure Christian in the sense that I should spread the "word;" I am a Christian because I believe in the order of things that is based on God's work. I personally feel closer to God than I ever did since I seriously got involved in the creative artwork. I . . . look to myself and God for the new work that I create rather than to (visible) nature scenes as subject matter. This I do for study, but not for real creative work.

Took member's paintings into Seattle for the state NLAPW [National League of American Pen Women] show at Seattle's Bon Marche. I like Seattle for cultural interest they seem to show. Received invitation to show at Kirsten Gallery. I like Richard Daisenai Kirsten for his attitude in art and Buddhism. I would like to show there soon. Will take in 4 works soon.

Being a human, I have wonder(ing) thoughts and longing for people I like and respect. Not easy to communicate. It is a painful feeling in my heart. The pain turns into tears and/or smiles and inspiration for new work. Nice thoughts bring on nice work. Beautiful, loving thoughts bring out beautiful painting—universal beauty everyone can relate to whether realistic or nonobjective style of painting. Keep my attitude filled with love, personal and general. I dream of such love nowadays. Must express in colors and forms. Much to be experimented.

March 22, 1980

As for myself being prejudiced [against] . . . In Japan, I was an American and a Nisei outside of the native Japanese. [I] read my diary of 33 years ago and came upon my suffering as an American citizen living in Japan. Return here and am a Nisei still apart from all the Nisei, and a Japanese among Caucasians, not quite "in" with the colleagues. Except Monte Morrison [former professor and now a friend] considers me as a

*person. It's good enough for me. And I do have a family whom I care
for deeply and have the respect of . . . This is really an important part
of my life as well as the fact that I found out we are all alone and that
we must find our own adjustment and happiness in this lonely world.
Really I'm alone but not really lonely. I prefer to be isolated so as not to
get too much outside influence, and narrow down my road to singular
path, which is in art. Then I get too isolated and have a great need to
go hear the lecture or see a respectful person, and ready to go into
narrow path again. Seems like this is my pattern of life and I like it very
much.*

*Mr. Ishii [lecturer at UPS from Japan] wrote in his book to say the
importance of getting rid of knowledge, that is, "left mode" intellectual
approach must be denied and go from the soul.—Reminds me of Julian
Jaynes' lecture going back to the bicameral mind and leaving the
logical, learned consciousness. Gosh wish I can have time to discuss
with Monte Morrison . . .*

March 26, 1980

*Yesterday moved into the rented studio at Marymount Academy. Paid
rent for 6 months. It's a place like going into a monastery to meditate
and paint. So exciting the thought of doing canvas works and ideas
are flowing . . . Conversation with Monte M. was really pleasing. It's so
mellow and gives me the sense of harmony—the right sort of chemical
mixture. Integrated into finding a new person in me that "I like." I like
the feel I get just standing near him. It's a moment between "past and
future," "Bible's 10 commandments and mundane world." Catch while it
lasts, cherish and enjoy the sensual moment of exchange of words. It's
just right. Felt I can talk to my heart's content!! Finally, someone!! Even
for a moment.*

*. . . Practiced sumi-e for a demonstration. Felt good about it.
Constantly revising so that best repertoire can be presented . . .*

*Have begun to write down the nebulous shapeless "soul" or
consciousness I find in myself that steadies my life today. It's parts, yet
whole; it's good—it's integrated, I feel the strong woman in me, yet
sexless, no goodness or badness, no negative or positive, it feels whole,
suspended, fragile, soft and warm. All that seems to help . . . give me
confidence for greater possibilities. Infinite. Just to hold for a moment
longer. All triviality disappeared for a moment and only the word "love"
and "truth" came to my mind. Thank you for a great day of self-
discovery. Very anxious to get on with the canvas works.*

April 13, 1980

In the wake of a great demonstration at Tacoma Art Museum, I heard from National League of American Pen Women in Washington, D.C. that my sumi collage, "Water's Edge," received a $100 merit award. It was the best of the "Tamashiro" ["symbol of soul"] series where recycled sumi ink and rice paper were used along with lavender-colored rice paper, and calligraphy of my original haiku is written in or integrated with the textural part of the design. I'd like to keep that for posterity and not sell it. It has all my thoughts. Poetry, ethical and moral environmental-consciousness inspired ideas all synthesized in it— my whole attitude about life is in it. Although someone wants to buy it for $450. It's a painting that was in the museum show last August, 1979 [Tacoma Art Museum's University of Puget Sound faculty show]. Yes, this is really a humbling experience. I'm really emotionally ready to do larger canvas work . . . Wish I could go to Washington, D.C. to receive the prize.

May 19, 1980

Mt. St. Helens . . . erupted yesterday morning. Saw the most awesome smoke spewing yesterday. What a flow of energy!! Took some photos for posterity.

As mother, much to worry about the children—boys. Reading Lawrencian psychology is really helping me to understand our boys— "Sons and Women" theory of emotional relationships. Am going on to read Gregory Bateson's "Mind and Nature," and for the summer read "The Courage to Create" by Rollo May.

June 1, 1980

Finally the day came to demonstrate-talk at the Seattle Art Museum on Japanese sumi painting technique suiboka-ga [literally, Japanese water ink painting, a technical word for sumi-e]. It's been a long germination period that culminated into today's activity. Yosh and Ray stayed and joined the audience. Had mixed feeling about this, but somehow it helped me on the contrary, I wasn't as nervous. Audience of over 100, near 150 I believe.

As I write this, I feel really humble to be given such an opportunity . . . I know I was being truly myself, expressing how I felt about, no, how I practice, what I understand to be Zen sensitivity. So I was able to speak in my own words, which the audience can identify with.

My emotional state has been doubtful no matter how at times I felt good about balance in "life happening," "intuitive cognition;" but the

teary sadness . . . creeps into my mind now and then. I know it's the idea of having to forgive someone else, namely the stepmother and the dead father. I thought I did by having visited her, but perhaps that isn't enough. It still haunts me. I must do something to express this. What more can I do, I know stepmother has a lot of property to sell to build headstone for him, with three boys in college, it is just impossible for me to put aside cash. Why do I have to be put in such a responsible position?. . . I do have pain in my heart that bleeds tears. Perhaps this is a part of the learning experience and that I will learn a great deal from it and in place of tears, something beautiful will be seen on canvas.

. . . after 2 months in self-exile at the studio involved in painting, I am bothered by the fact that each canvas is getting separate treatment or response and each one is different. I realize they are nowhere near finished. While at the same time, am truly confronted with the "self," the raw "self," and emotionally the unresolved father-daughter relationship is giving me pain and tears. Is it because of new awareness or am I truly facing myself with the idea of honestly forgiving him for what he did to Mother? This is what I have been enlightened about in order for me to go on. Such thoughts still hanging in my mind.

June 2, 1980

Talked over with Dr. Rich [minister of Whitney Memorial Methodist Church where I belonged and kids went to Sunday School]. *The pain that seems to hit me and turn to tears. Forming . . . new artwork seems to have brought on this state of mind. It's my past that's coming out in chronological order: so vivid it gives me the pain.* [Dr. Rich] *said it's all part of self-creation, I believe in that. If I can get over the hump of this guilt or whatever I feel about Father and Mother and the whole family bit. I have to weather through. Not much I can do at this time, yet perhaps not having talked with him* [Father] *is the main hang up. Perhaps I can write a fiction someday, I will see.*

Dr. Rich suggested writing a letter to him even after he's gone for my release of tension. Scares me, I will have to deal with it.

Am anxious to go to the studio, when will I go?

June 4, 1980

[The suggestion to write] a letter to Father was strange. Not in my grain. Felt really uncomfortable all afternoon yesterday . . . The last time I confronted myself it was 1966 and I cursed to God, then. My prayers did not help the despair I was in. This time it seems as though

God was telling me to confront myself and express my true feelings. I never did talk about how I felt about Father. Very negative, but God seems to call me this time to face it, cry it out and forgive him. It was a strange experience. Why now? Pain of rebirth of my painting opened up past wounds to drain out the poison by expressing my true feelings about him. Namely, hatred, resentment . . . The pain of rebirth somehow got associated with the pain of physical hurt from burn and pain of not receiving his love. Really finding out about parental love, Lawrencian mother-son love . . .

Michelangelo once said, "artwork will show that beauty when one thinks like a saint."

Received a call from Midori Thiel wanted to know more about the calligraphy teaching. Will share.

Received call from the Wing Luke Museum. Received 2nd prize in painting category—"Tamashiro #8." Will go to the dinner and accept award. It's been a good day with watercolors in the morning and visits and talking about somewhat esoteric things we are engaged in.

Calligraphy and Ray

1980, AGE 50

In 1980, Chuzuko Paz, a friend and fellow artist, invited two calligraphy teachers from Japan to teach in Tacoma and exhibit. Misao Aoki, master calligrapher, and Kuniko Oishi, his assistant, stayed about eight weeks in 1980, exhibiting at Pierce College and offering classes. They came again in 1982, exhibiting at Evergreen State College, and also in 1984, exhibiting at the Tacoma Art Museum. There were seven of us in the classes: Mary Bottomley, Bill Colby, Ann Inouye, Chuzuko Paz, Midori Thiel, Selinda Sheridan, and myself. Instruction was held in the home of Ann Inouye. We called ourselves the Yuhokai calligraphy study group. The "yu" came from Mr. Aoki's artist name, Yukei, meaning deep or mysterious valley, and the "ho" from the assistant's name, Kuniko ("kuni" becomes "ho" in the Japanese language when integrated into a compound word). What a pleasure to learn the art of calligraphy from a master and form rich friendships as well.

We took a sightseeing trip by ferry on their first visit here, and during that trip Mr. Aoki gave myself, Mary Bottomley, and Ann Inouye our artist names. It is a tradition for teachers to give students a professional name. I received the name Yumi. The "yu" came from Yukei's name, meaning deep, mysterious, or ethereal, while the "mi" came from the middle syllable of my first name, Fumiko, "mi" meaning beauty. *Yumi,* "deep beauty." I often use Yumi for signing my sumi-e, calligraphy, haiku

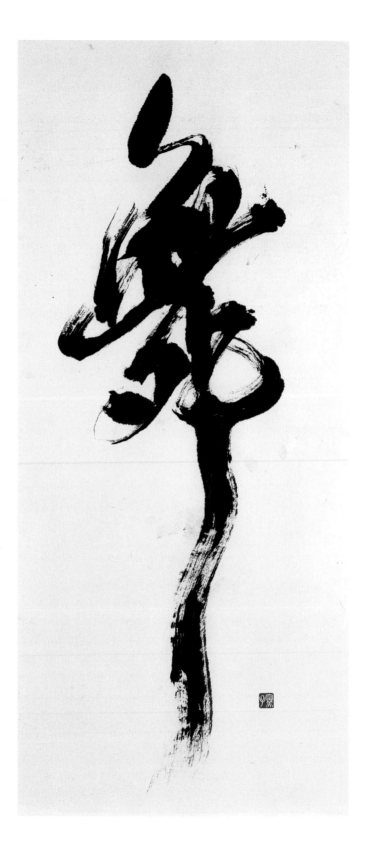

Dance, 1980s, ink on paper, 31 × 14 inches. A calligraphy with the single character for dance. This was made before master calligrapher Misao Aoki came from Japan to teach a group of us in the 1980s. After seeing my work, he told me, "Don't change, just proceed."

Seal with my artist name, Yumi, meaning "mysterious beauty"

poetry, and *haiga* (combination of poem and image). Mary Bottomley and Ann Inouye were also given names with "yu" at the beginning, Yuka and Yuko respectively, "deep flowering" and "deep fragrance."

I loved writing calligraphy, the brush flowing with wet and dry strokes across the rice paper. Such explorations helped me prepare for sumi painting. Sumi-e in many ways derives from calligraphy. Mr. Aoki was a good teacher, but I was doing expressive calligraphy anyway. I had found my way back to calligraphy on my own, remembering my childhood lessons of thirty-years earlier, and also from the influence of my artist friends in Tacoma, Mary Bottomley and Ann Inouye. I didn't gain that much from his visits. Of my one-character paintings, he said, "Just do what you are doing. Don't change."

Not long after I received my artist's name, in 1980 at age fifty, one of my twin sons, Ray, took his own life while a junior at Pacific Lutheran University studying music. He was an excellent pianist and loved Chopin. The morning of August 2nd he took an overdose of aspirin. I guess he became scared because he put himself in the hospital. They pumped his stomach. They called us and of course we went. In the hospital he said, "Mom, you wouldn't understand." I said, "Try me." Whatever suffering he was going through, I wanted him to tell me and would have replied with loving intentions. That night he took his own life in the hospital, hanging himself with sheets from the bed. He was twenty-one. What a shock for all of us.

A few weeks later an envelope appeared in the mailbox. There was no return address and the writer didn't sign the hand-written letter. The author wrote that Ray's death was all my fault because of the pressure he felt that he should follow the family's wishes and finish school. They had wanted to go to California. "We were going to move to L.A. . . . it's all your fault Ray died—he hated your pushy ways," the letter said. "This world lost a wonderful musician and a nice person. Gay people have rights too. Please try to remember that." The person blamed me, the mother. I was stunned. Ray was under various pressures, including preparing for the Van Cliburn International Piano Competition. We did encourage him to finish school, to finish what he started and get his degree. But if there was a reason to change, we would have been supportive. It's OK to change. But it never came to that. It was too late. I knew he was depressed, but I didn't fully understand the situation or know he was involved with another person. I wish I had known. As his mother I should have known.

September 5, 1980

A long spring and summer months with Ray has ended when Ray took his own life by hanging. I was really worried for a long time and had the privilege of even experiencing what he was going through. It was God's help for me to experience the sinking "nothingness" feeling that Ray was experiencing. Really Lord wanted me to know how it is to be in that state of mind so that I can understand Ray . . . all along I had uneasiness trying to understand him, as he was going farther and farther away from us even as he was present—he seemed to be suspended in limbo—not knowing which way to go or what to do.

. . . He is at peace now. I'm in a way happy for him, but as a mother, I have terrible "pangs." I guess they are going to be here for a while. My life is based on one pang after another. The "pangs" and "tears" are what help enable me to see the beauty in this world, this I know. But must beauty be so painful, and the pain that one feels turn into beauty?

September 24, 1980

You have been in our hearts daily, hourly. Can't get out of my mind. Perhaps I should have let you go emotionally long ago when you were in high school. I felt responsible as mother. So I did my job but you being you, you responded quite differently than others. You were such a good kid! Yet I worried a lot, because you perceived differently and quite deeply. My worries and instinct were proved when I read your letter, "A Letter to Myself." You did struggle with your identity problem basically, didn't you? It must be a very difficult problem to live with for it's physiological as well as psychological. You said, "you don't understand." How can one understand your inner suffering only you knew. Perhaps only this mother will understand. Perhaps dad can't. I won't say anything unless he seems open to new thoughts and ideas.

. . . After I read your letter to yourself [found some weeks after Ray's passing], I felt I understood you perfectly and felt a new leaf being turned over, for now I feel I can release you from me. Now, Ray, you are happier. Continuing on with your progress in the other world. I believe you are. We miss your lovely piano music. It is a dream. You are OK. I can go on now with this new knowledge about you. I'm going to create a lot of beautiful painting thinking of you: the privilege we had you for 21 years and the many happinesses you have given us, OK?

Shodo [calligraphy] exhibit preparation takes up so much time, haven't been to the studio. Yukei Aoki and Kuniko teachers are here and keeping us busy.

October 15, 1980

In calligraphy class, we learned a lot about bringing out the life of our own through the tip of the brush. Write with one controlled breath. So we stood on the floor, took the brush and put our whole effort into it. I organized, coordinated the library exhibit, and the opening demonstration activity as well. I interpreted for Aoki and wrote out the concept of calligraphy. After that I came to a certain conclusion about my understanding of Oriental calligraphy.

I used to think that calligraphy was a dead end and that it is not creative enough; but [it can be equated with the art of sumi-e, whose goal] is to bring out in any living motif of your choice the essence of that particular beauty and give life to it. . . . The artist takes the word he feels deeply about and practices enough to bring out the essence of beauty in it, thus giving life into that particular word. So there. It may take a whole life to bring out the essence. . . . Therefore calligraphy is another facet of the artist's expression.

For the library exhibit, I used "dragon," which I have been practicing for 9 months. I wanted to mat the dragon so badly. I practiced and did get one out which both teachers approved. Mr. Aoki shook hands many times and said, "It is becoming your own." I of course don't feel that yet. I will continue to practice and finally do a painting as well. Calligraphy dragon is 1st step to painting dragon. . . . Been reading "Man and His Becoming" by Phillip Phenix in preparation of discussion with the Prof. [Monte Morrison]. Read twice . . . "Becoming, growth, change are justified by the being to which they lead. . . . Time and eternity are indissolubly wed. The arts beautifully maintain the sense of this union, which is so essential to the understanding of authentic human existence. On the one hand, they provide for freshness and novelty through acts of creative origination. On the other hand, they allow for the preservation of consummatory values through the fashioning of enduring material objectifications."

December 6, 1980

Read John Lillly's "Center of the Cyclone." [He was] a psychiatrist who experienced freedom of soul and its implications to become a healthy, integrated man. His search for the depth of consciousness ended

up by realizing that there is something more powerful than God in the realm of Cosmos as man's consciousness or soul can go or leave "planet Earth" and reach the state of "high indifference.". . . In terms of painting, here one can make or find his own creative choices for design, color etc. confidently and assuredly. Because of my awareness and understanding of Ray's death experiences and my own last May concerning getting rid of "karma," I believe in most of the parts of Lilly's thesis. Simultaneous "high-low" soul positing is really a learned experience and this helps to get "into other people's souls" for empathy purpose. It was really something to read about and know or believe that we can all get rid of hang-ups (karma) and come to the place where our soul can be healthy and free . . .

So another study I'm making is Delacroix and his journal as he is the father of the Impressionist school. Really involved in reading his journal and "Eugene Delacroix's Theory of Art" by George P. Mras. To read both is beneficial.

Delacroix speaks of sketching unfinished works as stimulating of the responsive imagination by a proactively unfinished technique. "Lack of finish produced greater brilliance of effect." "In order to avoid dryness; in order to achieve spontaneity and brilliance of effect."

Great art—Soul is the source of creative imagination. External nature is the source of creative imagination . . .

A part of me is in great need of beautiful Experience—the relationship with person to whom most anything on Earth can be discussed with ease and trust. It's no longer in my imagination as wishful thinking. Not a dream, but a real fantasy come true for suddenly last Tues. M [Monte Morrison] brought over the films we ordered and had a long talk about the books we read. How stimulating. It just is. It satisfies my hunger to talk about ideas and responses to them. I'm a student of his till the last step. I will conduct accordingly fully realizing the platonic relation is the ultimate to the beautiful something we hold. It's so beautiful it's hard to describe except that I'm so inspired by our conversation that the next day the largest canvas was prepared to be "attacked" . . .

January 1, 1981

X-mas came and went with many events that were made or planned to happen.

For lack of other ways to keep our spirits and morale high for the holiday, four of us family went to Ocean Shores for 2 nights [son Howard had obligations]. What a beautiful experience. We walked the

beach in the warm storm—warm wind generated in Hawaii and swept the Northwest with record high winter temperatures . . . We were walking the roaring Pacific beach. From the 3rd floor [of the motel where we were staying] we felt like we owned the whole ocean in the palm of our hands. We walked in the rain, the wind blowing on our cheeks to invigorate and purifying our insides at the same time. We splashed in the water. We ate, rested and final morning we walked the sunny beach. What a beautiful warm sun after cool storm that purified our senses—clarified at the same time. The Millers—Vern and Eleanor— were there too. So they have helped us out a lot passing the time without much pain about the loss of Ray. Can't fathom at times that he is gone forever. The wind helped me let go of him. . . . Came home with the renewed thought that 1981 is going to be a new beginning for everything. Live for now and go with the wind. . . . Such a sense of harmony.

Been reading Alan Watt's "The Book." Almost finished . . . helps one realize that opposite extremes are polar and the poles need each other. Many good ideas here seem to relate to me. There's always inside me the restless Self waiting to explode and the reason calms it down. It and the self are the same and the one?

May 9, 1981

. . . Thank you God for my lot. Two boys have jobs and my delight turns to pang about Ray, but I need this pain to go on painting I suppose. Thank you again. Freedom ⇆ responsibility.

I was disappointed not to sympathetically talk about Ray's death with my husband Yosh, or with Ray's twin brother, Richard, but we never did. They weren't interested to do so. They were ashamed of Ray's sexuality. I wasn't. Not everyone is the same. After the suicide the family seemed closer in some ways, but in other ways not. I was suffering. Of course I felt guilty. A mother's responsibility. It was hard. When a parent loses a child to suicide, everything changes.

Still I was painting a lot, absorbed in art making and selling artworks to keep two kids in college. Staying busy with art helped. I was reading inspiring books and doing calligraphy. The Yuhokai calligraphy study

Dear Lord. "Thank you for beautiful Experiences in life —

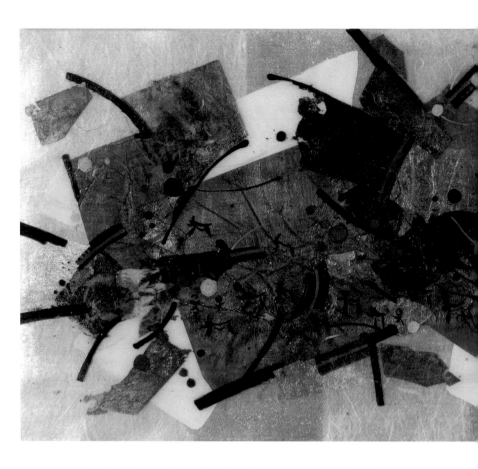

20th-Century Alchemy, 1984, mixed media including gold leaf on acrylic sheets, 10 × 31 inches

group was active, but the last visit of teacher Mr. Aoki in 1984 did not go well. Mr. Aoki felt he was not getting the audience he wanted and seemed to expect more as an honored guest. We did have an exhibit for him at the Tacoma Art Museum, but he wasn't happy with it.

I had my friendship and conversations with Monte Morrison, or M or M.M. as I sometimes referred to him in my diaries. He never said much directly about Ray's passing but he stood by.

Ray's passing is a pain that doesn't go away and always brings tears. One help soon after was starting a large painting on canvas with the idea of recording my thoughts. It was an abstract work with shallow pictorial space, and in one corner were some arcing lines representing the Narrows Bridge. That was the initial design. Ray could not pass that bridge. It was like a diary on canvas where I could paint and collage as if letting Ray know what I was doing. I felt this connected me to his spirit.

Another solution was to go into quiet meditation sitting on the floor cross-legged with my back against the wall. I sat in the beginning for ten minutes, and, as the days went by, I was able to sustain quiet and worked up to forty-five minutes daily. That continued for nearly three years. I

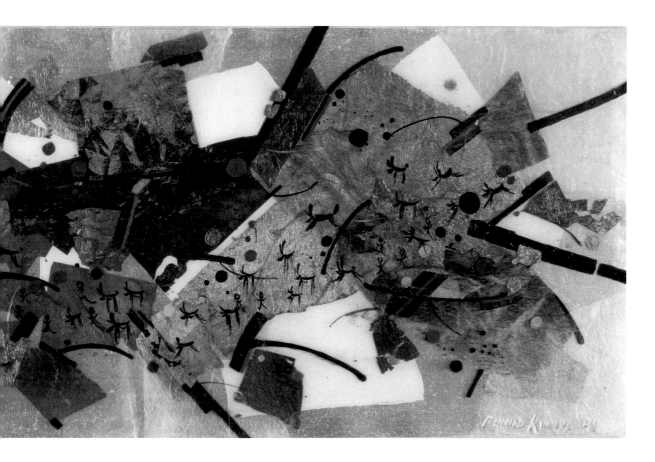

learned to be tolerant of myself. I learned about living in the moment and my psyche seemed wider.

One time when I was making jelly with sour cherries from a friend's yard, I realized I was totally into the activity without any other thoughts but jelly making. I loved the dark color of the juice, and the clang of the ladle as I skimmed the bubbling foam. I realized the process of jelly making was a meditation itself, as really was all of life. Attention to small details. Sensation before words. To do the thing with your whole being in the moment. It was such a flow from beginning to end, making the jelly.

DIARY (age 54)

September 9th, 1984

. . . *Went to Faculty Opening of our art exhibit* [at Tacoma Art Museum]. *Felt mine was fine, but I need to travel to expand my mind-space. Thought it seems as tho I had discovered the immensity of*

mind space similar to cosmic space. It doesn't manifest in my artwork. They are small and tight like I live in this tight little house. I need more space. Got to converse with all the professors. Nice to talk to Bob Vogel, Dr. Fields, Bill Colby, too. Yes, M.M., also. I thoroughly enjoy him. Talked of N.Y. (only a lot of commercialism). Not what it is thought to be—center of artistic activity, that new ideas begin there. He thought I should read Castaneda's "Fire Within." I will!! He is a man liked by everyone—He is a "universal man."

Visiting Senjuin Temple
1985, AGE 55

In 1985, I had a chance to spend two weeks in Japan, including a day at Senjuin Zen temple in Akita prefecture in the northwest section of the main island near Kawabe City. I was introduced to the Zen priest through Dr. Takeda, the same relative in Japan who had bought my fuchsia painting some years earlier. Dr. Takeda had written to the temple on my behalf without success. He suggested I write to the temple priest directly. So I did, explaining that I had lived in Inaoki village near the city of Sendai for seven years in my youth, that I understood Japanese, and was an artist who wished to learn more about Zen painting and calligraphy. The priest responded right away welcoming me to visit. He said that he was raised in that very same Inaoki village and that his mother had a Zen temple up the hill. She was an *osho-sama*, a woman Zen priest who took care of village events: celebrations of birth, death, Girls' Day, Boys' Day, and other festivals. What a surprise that I had heard the gongs of his mother's temple as a youth in Japan, a welcome sound drifting softly down every morning from a distant hillside.

I traveled to Japan in October with my dear friend and artist/calligrapher Mary Bottomley, also Japanese American. We took the train, then taxied to the temple to see the priest, Mokusen Saito. It was a cool morning. Persimmons and grapes were ripening in the countryside. The fields were bright with rice plants swaying in the autumn breeze. From the taxi window we could see the huge wooden Zen temple up on the hill. We arrived about an hour late and entered the great hall. All the supplies for painting and calligraphy had been laid out on the floor in preparation. Members of the temple and ladies of the kitchen in white aprons sat on their knees on the tatami mats, waiting. The scent of incense hung in the room. There were also village officials and a small television crew—word had gotten around that some foreigners were coming to learn Zen calligraphy and painting from the priest.

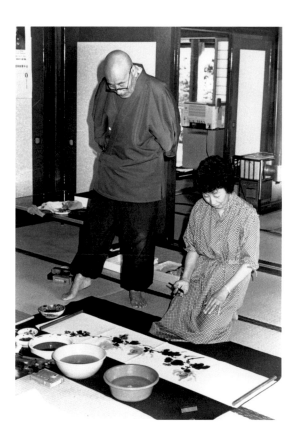

I visited the Senjuin temple in Japan in 1985 and met with the Zen priest, Mokusen Saito. I'm painting a composition of persimmons and leaves. The small bowls hold color that I brought with me. The big bowls hold clean water. The priest was very interested in my use of color as he used only black ink in his paintings and calligraphy.

Mokusen Saito was tall with a commanding stature and a firm handshake. He began by painting a Daruma image and then wrote Zen poems in graceful calligraphy on large sheets of washi rice paper. The action was all observation. Then I was invited to paint. I was surprised. I wasn't expecting to be painting in public. But I had my painting supplies, and on the spot chose the subject of grapes and persimmons, which I was well accustomed to painting at home as they were popular subject matters, and which I had just seen in the countryside. I knelt, dipped my brush, and mixed my colors for shading and surface textures of the fruits. Mr. Saito commented that he had never used color for his paintings (monks typically use only black ink).

He watched intently. I brushed the persimmon painting first, fruit and leaves, then on another sheet of paper, the grape one. With the grapes, my plan was to depict one large ripe purple cluster and a smaller one along with sinuous vines. The larger cluster I painted as planned, but I forgot to add more blue to the brush for the smaller one, and the fruit appeared pink, not purple. I almost screamed, "mistake . . ." It was too late. I left it pink and called it finished. You can't correct ink-on-paper painting.

The priest pinned my paintings of persimmons and grapes to the wall and spoke his opinion to the audience and me. He was very interested in how I used color. Saito sensei ("sensei" means teacher) commented the artist had not followed her plan, but it was not a mistake. Things happen and those choices are not wrong. "The larger cluster is ready to eat, but the other pink one will be ripe soon and ready to eat in a few days," he said. Ready to eat in a few days? It was a surprise the way he spoke his ideas, with both insight and humor. My "mistake" was an example of letting go to allow what is to come forward, and perhaps an example of some kind of collective or universal consciousness. The way he expounded, it was a revelation. One lesson was, paint from one's heart with less thinking. I gained great insight from this trip and more confidence in my pursuit of Zen art and intuitive painting. In fact, I returned from the temple trip changed. I felt sure I was on the right

Left

Calligraphy and painting by Mokusen Saito, 1985–86, ink on paper, 13 × 10 inches. Mokusen Saito sent me calligraphy and Buddhist wisdom from his temple in Japan to copy or sometimes just as a gift. This calligraphy with persimmons he painted using color, as he had seen me doing when I visited.

Right

Calligraphy by Zen priest Mokusen Saito, 1985–86, ink and paper, 24 × 13 inches. This one reads, *mu shin ki dai do,* and translates:

> *return to no thought*
> *is the great way*

The small characters at left are his signature, and read "Saito Mokusen written by." Saito was his family name, and Mokusen his given Buddhist name.

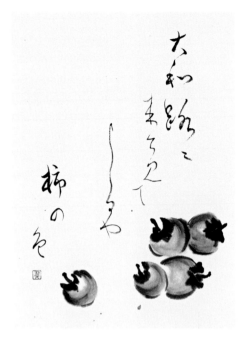

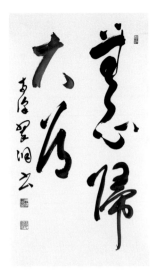

track with the idea that you don't have to worry, just accept what comes from your imagination, intuition, and unconscious, and work with it.

We left the temple with a sea of Japanese faces waving sweet good-byes. I continued to study with Mokusen Saito through the mail. Every other month he sent me challenges and assignments to copy on rice paper folded up in an envelope, and I sent him back my works and responses.

One time he sent me a haiku poem and painting inspired by the persimmon painting I had done during my visit—using color since I had showed him! The poem includes the Japanese word *yamato,* meaning peaceful country or great harmony. It is an ancient term for Japan that originally referred to the area around today's Sakurai city but became by extension a name for all of Japan.

> *yamatoji ni*
> *kite mite shiru ya*
> *kaki no iro*
>
> *I finally came*
> *to the peaceful country and saw*
> *the true color of persimmon*

One of the assignments he gave me was to do something based on three eggs, either a painting, a poem, or a combination. I thought and thought about this, and drew, and was always composing and imagining in my mind. One painting I made was based on having watched a mother bird coax her brood to fly seven years previously. The nest had been in a rhododendron outside my kitchen window. There were three chicks. One day there was such a racket. The first two birds flew. After an hour the last one finally took off. Then there was a silence I can never forget. I was inspired to depict three birds just hatching in several paintings, with one egg showing a chick emerging, the second one having only a crack, and the third one smooth and unbroken with the chick still inside.

The correspondence with Mokusen Saito lasted two years, until, sadly, he passed away from complications of throat cancer. When I think of him, I am grateful for his teachings about the Zen creative process, and hear the village temple bell where his mother lived and he grew up, and where I spent seven years as a youngster.

DIARY (age 56)

November 5, 1986

Yes, Japan trip was a very memorable experience. . . . Learned about mind process as new awareness I didn't know when with Mokusen Saito. Also, I wished I had more time with Mr. Hansho Tanaguchi sensei in sumi-e art in Kyoto.

Mokusen Saito said he had known me for years. Such a strong person—yet gentle. His eyes are piercing—he was seeing me through and through; and I might have felt and seen a glimpse of the Buddha, or dharma-san (Darma).

Very busy with art. My opening day and night at Art Concepts [gallery in Tacoma] was something I never experienced before. So cozy and intimate. Felt a warm reception. So many people. 1/3 of the works were sold by Saturday. More might be sold.

Puget Sound Sumi Artists

1986, AGE 56
TO PRESENT

After visiting the Senjuin temple, and also having had some lessons with the director of the Nanga School of sumi painting in Kyoto, Mr. Hansho Tanaguchi, I was energized. Japanese aesthetics had long been influential in the Northwest, but mostly visible with Japanese gardens and residences built in the "Northwest style," that is with rectilinear elements, openness to nature, and wood inside and out. But there was not much

My son Howard graduated from Washington State University in 1987. My husband Yosh is at left, then myself, daughter Jeanne, Howard, and at far right my son Richard with his fiancé, Marcia.

for people interested in pursuing brush and ink painting or traditions of calligraphy. I asked two friends and veterans of the Yuhokai calligraphy group, Mary Bottomley, a certified calligraphy teacher, and Ann Inouye, an ikebana flower-arranging teacher, to help organize a sumi artist painting group. We called ourselves Puget Sound Sumi Artists. There were fourteen charter members in 1986, many of them veterans of the Yuhokai calligraphy fellowship. The mission of our group was to encourage members "to advance his/her standard in artistry in sumi and related work and in Asian calligraphy," and to "foster the appreciation of sumi and brush calligraphy art in the community through exhibitions, demonstrations, and by teaching in schools and other venues." I was the first president, or coordinator as we called it in those days.

Our initial activity was a juried exhibit of Asian-brush calligraphy and sumi painting. One purpose was to introduce PSSA statewide and find new members. Mary Bottomley, Dan Vesey, and myself visited Professor Bill Colby, one of my former art professors at University of Puget Sound, and proposed the university's Kittredge Gallery for the exhibition. Professor Colby was gallery director at the time and he accepted our proposal and helped guide the effort. A few years later he retired from the university and became a member and mainstay of PSSA. The exhibit in 1987 was a success, with two notable judges: Midori Thiel for calligraphy, and University of Washington professor and artist George Tsutakawa for sumi painting. PSSA exhibited at the Kittredge Gallery again in 1989 with Pat Bruzas as exhibit chairperson.

I guess there was something in the air about sumi art and Japanese traditions, because in 1988 the Bellevue Art Museum mounted, "Six Northwest Contemporary Sumi Masters," which included the

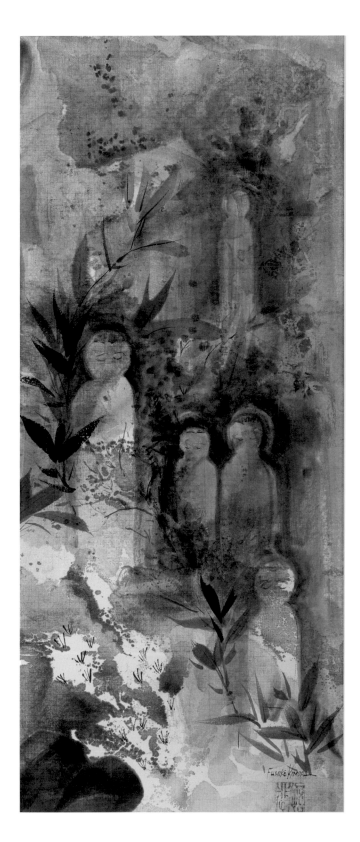

Jizo Family, circa 1992, ink on paper, 23 × 10 inches. Part of the "Pilgrimage to Nara" series I made after a trip to Japan in 1991. Jizo statues dot the Japanese countryside. There are five Jizo figures in this picture, symbolic of my family.

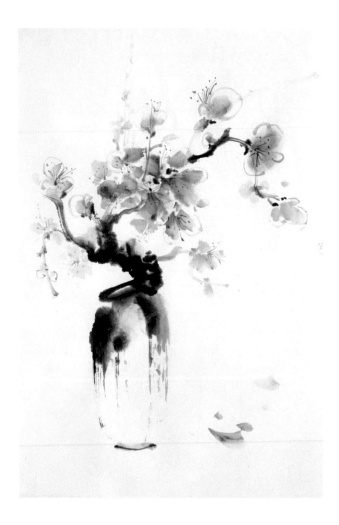

Plum Blossom, 1987, ink and watercolor on paper, 30 × 16 inches. This piece won first prize in 1989 at the National Sumi Society of America exhibit. It was later shown in Japan and purchased there.

well-known artists George Tsutakawa and Paul Horiuchi as well as myself, and in that same year Seattle's Bumbershoot Arts Festival hosted "Sumi Neo Tradition." My work had been receiving other recognition as well, for example a reviewer wrote, ". . . she knows what inspired brush-work is . . . melancholy underwrites her lyricism, structure underlies her buoyancy, and calligraphy gives her life great meaning . . . a brave and generously gifted artist" (Warren B. Wotton, *Tacoma News Tribune*, 1985).

In 1991, PSSA was invited to Kyoto to exhibit at the gallery of the Nanga School of sumi painting where I had taken lessons six years earlier after visiting the Senjuin Temple. Fourteen of us travelled to Japan on the occasion, including four PSSA members. PSSA member Elaine Ward demonstrated sumi painting at the exhibit. Locals were surprised to see a Caucasian westerner painting sumi-e, and the event made headlines in the Kyoto newspaper.

A Studio of My Own

2002, AGE 72–PRESENT

I had had modest studios outside the home on and off during the years, for example at Marymount Academy, but in 2002 in my early seventies I moved into a high-ceilinged studio in the Merlino Art Center in downtown Tacoma. At last. I had always wanted a large professional space outside of the home. I literally dreamed about it. My brother George and his partner Nina Bertelsen helped with the first few month's rent, and I was doing well enough with art sales and a busy teaching schedule to make ends meet. I stayed there very happily for thirteen years, producing many artworks, until the several flights of stairs were too much for my octogenarian body.

In 2015, I moved my studio back to my home, and not long after we celebrated the 30th anniversary of PSSA. The organization continues to thrive with about seventy members. I am the last of the three co-founders active, and I'm proud of the artistry of my fellow artists, the learning opportunities offered to our members, and the thousands of people from school children to seniors who have been introduced to sumi. The experience of sumi painting brings much joy to students young and old.

I have been fortunate to exhibit regularly since 1965. The ten years or so following my graduation in 1977 from University of Puget Sound with a masters in art education were especially eventful. I was in my early fifties, exploring different styles, reading widely about creativity, wrestling with the disconnection with my father and the loss of my son, and developing as an artist. I had an epiphany at the Senjuin temple and unburdened myself of too much worry and rationality, and I helped found PSSA. In this year of 2019, almost ninety, I still regularly paint and exhibit, give demonstrations of painting and calligraphy, and offer classes and private lessons.

Many of my works are hybrid in outlook, embracing both Western and Asian aspects. I have made playful works and darker ones as well, driven by my passions for nature, calligraphy, and abstraction. Sometimes they are large in size and ambition, and other times small and intimate. Sometimes they are nonobjective, and at other times representational, lyrical or psychological. Sometimes they include words, in English or Japanese, and sometimes not. I have never felt a conflict working in a variety of styles, Eastern or Western, or in combination. I suppose that mirrors my personal trajectory, a mash-up of cultures: an American born of Japanese parents who inadvertently spent seven formative years ages ten to seventeen in Japan during WWII; educated at an American university studying first chemistry and then Western art; and ultimately finding my way back to a Japanese sensibility through memory and love of nature. Perhaps my personal trajectory never reached escape velocity, but instead I am circulating in stable orbit around several guiding gravities.

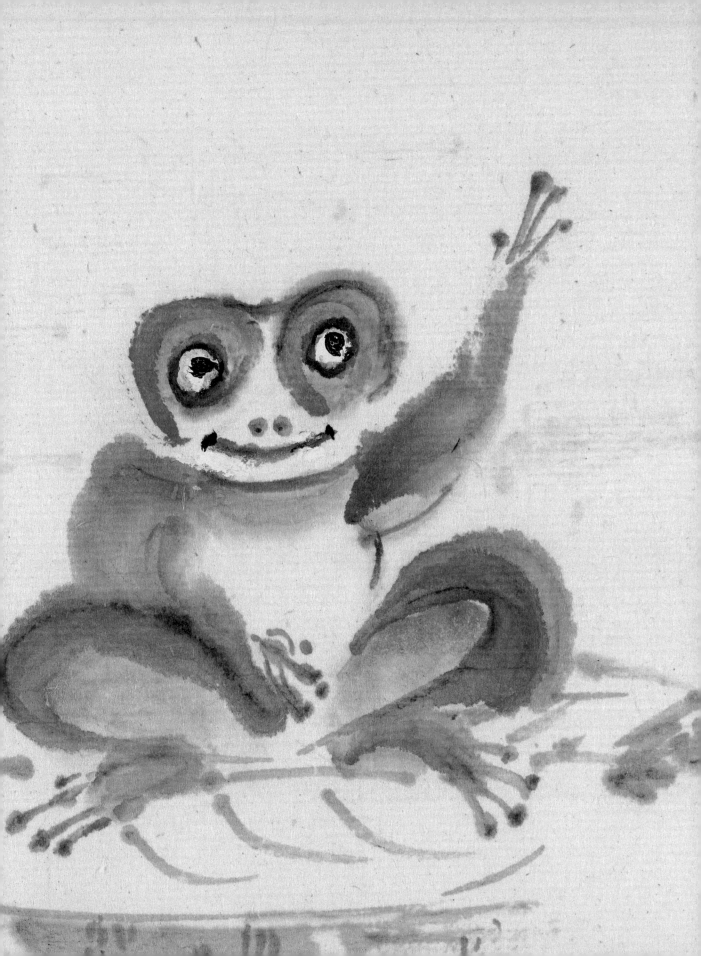

PART TWO

Art

the hum
of the temple bell
—the color of ripe grapes

—D.B.

CHRONOLOGICAL SURVEY

Representative examples of my artworks from 1955 to 2017, more than 50 years. Typically I work in series, so each artwork is just one of many of similar ilk. Some favorite subject matters I continued with for many years or revisited from time to time.

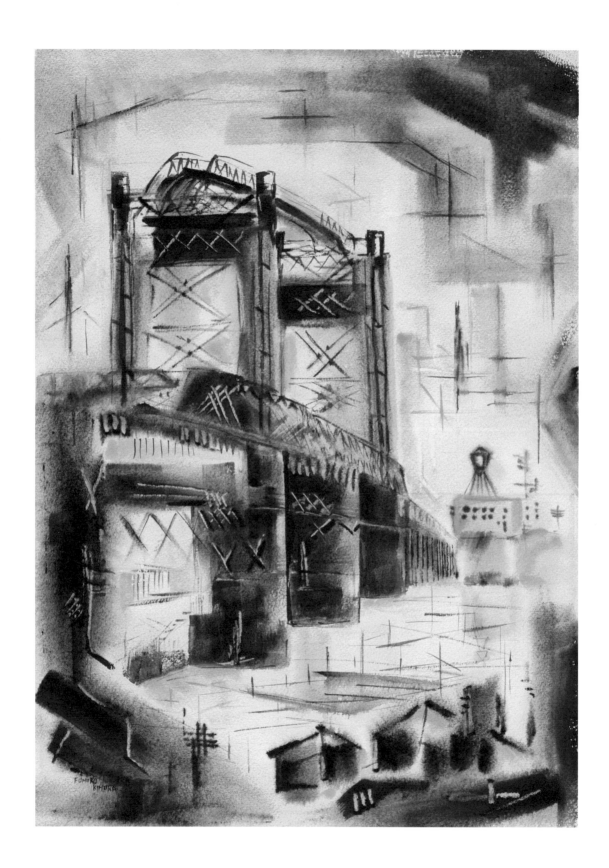

Opposite
11th St. Bridge, 1955,
watercolor on paper,
20 × 14⅜ inches

Two Butterflies, mid- to late 1980s, water-
color and ink on paper, 12 × 15 inches.
Part of series featuring different animals
including Tai fish, cows, insects, and tur-
tles. These were studies in composition,
pattern, and color.

Fumiko Kimura

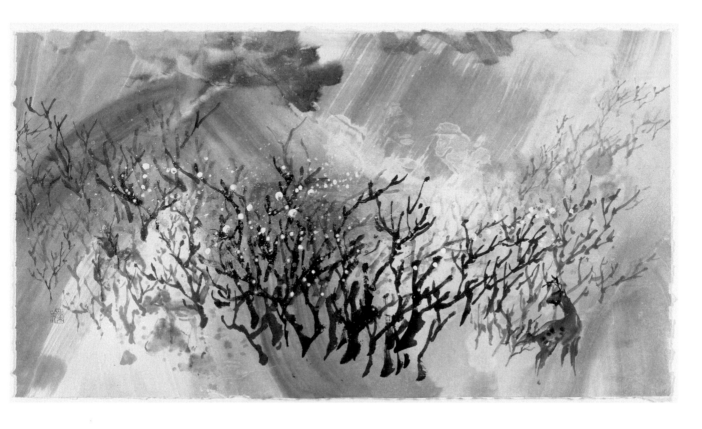

Opposite
Persimmons, mid-1980s,
watercolor and ink on paper,
24 × 16 inches. Paintings of
persimmons as well as other
traditional subjects like grapes
and iris were popular among
my clients and collectors.

Spring Journey, 1991, ink
and watercolor on paper,
12 × 23 inches

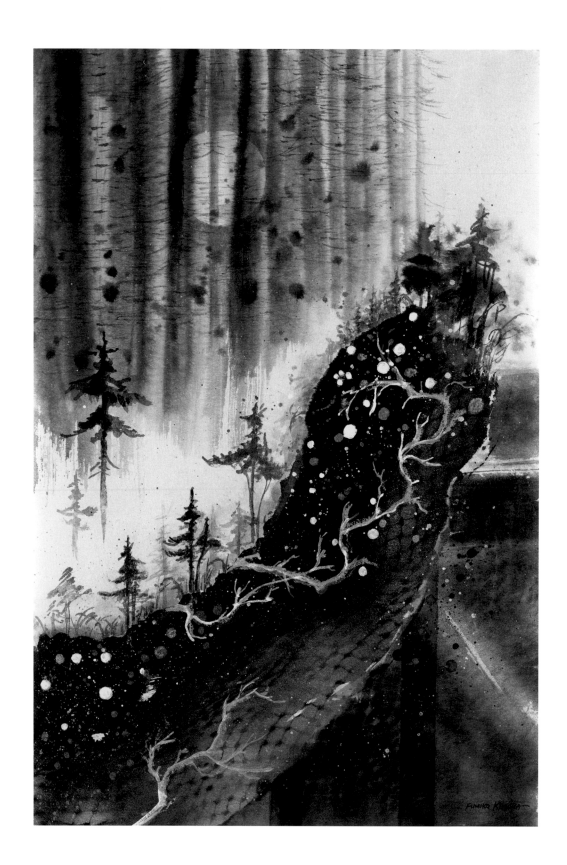

After the Shower, early 2000s, watercolor on paper, 18 × 10 inches. The character at center right means rain. The NWWS under my signature stands for Northwest Water-color Society.

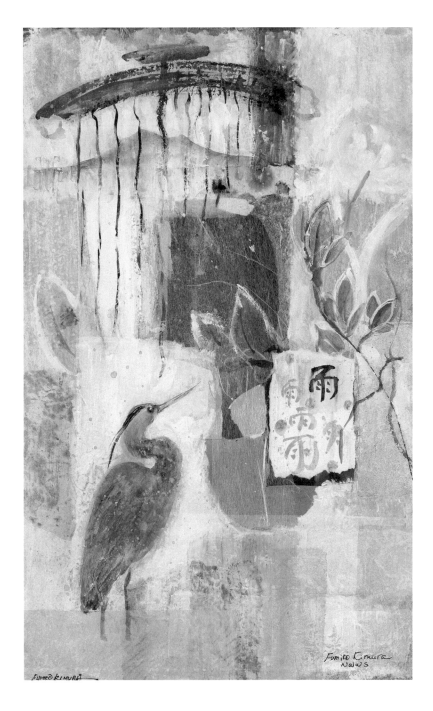

Opposite
Nurse Log, circa 1994–95, ink and watercolor on paper, 23 × 15 inches. Part of my "Clear-cut" series. I sometimes add a sun or moon to my paintings which can draw the mind beyond the main subject and create a broader perspective for the viewer.

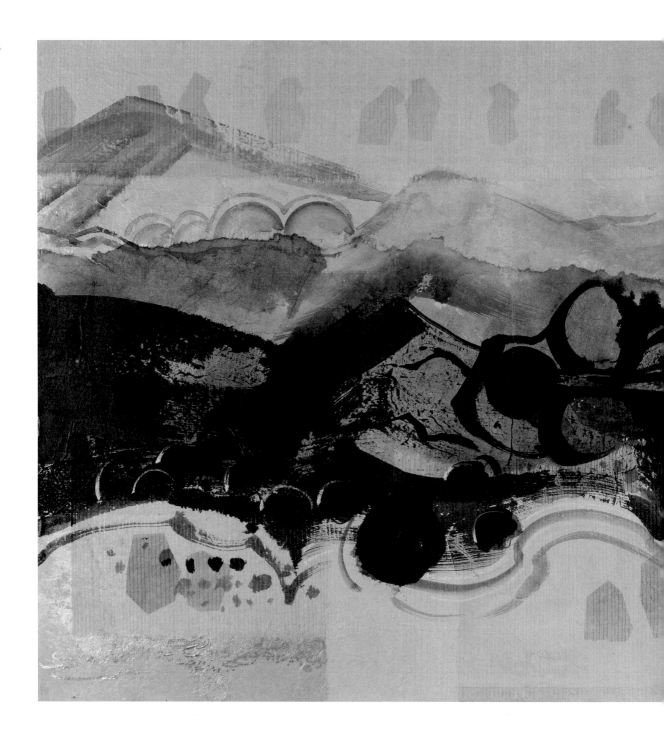

River Landscape, early to mid-2000s, ink and paper collage on paper, 23 × 48 inches. This piece is about water movement, the river running from land to the ocean.

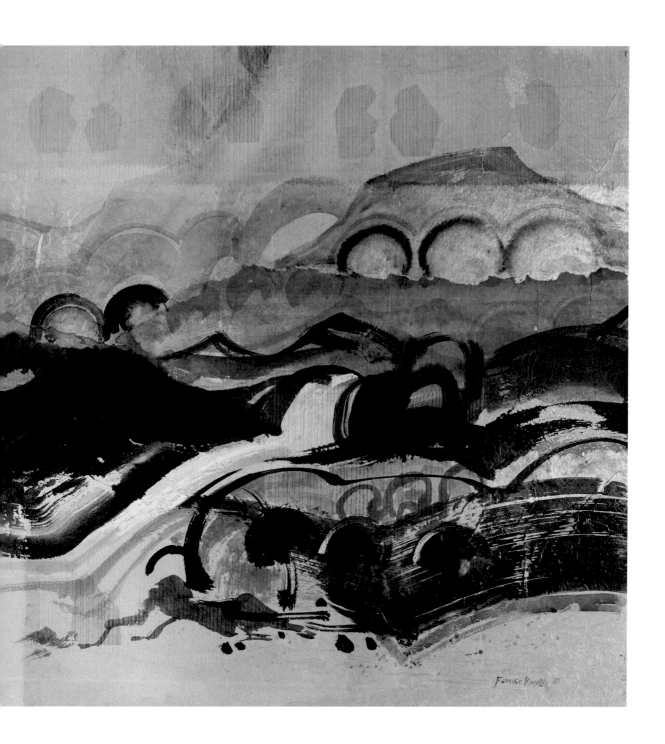

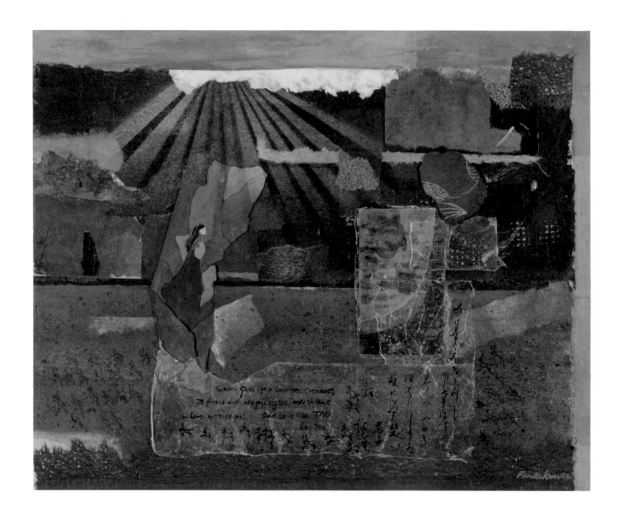

Untitled, early 2000s, mixed media collage on canvas, 15 ×
19 inches. The words are from the Tao Te Ching and writ-
ten with ink on sausage casing. The English reads: *Water
gives life to countless creatures / It flows and stagnates
in marshland where men reject / And so is like the TAO.*
The perspective lines push forward into the foreground
plane with energy and vigor. They are symbolic as well as
physical.

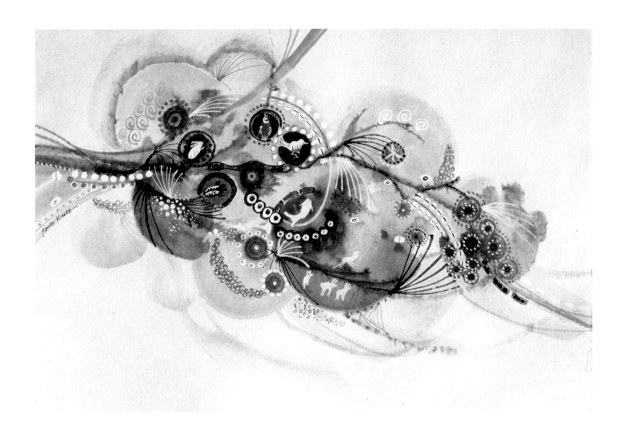

Microcosm, early 2000s, ink
and watercolor on paper, 12 ×
20 inches

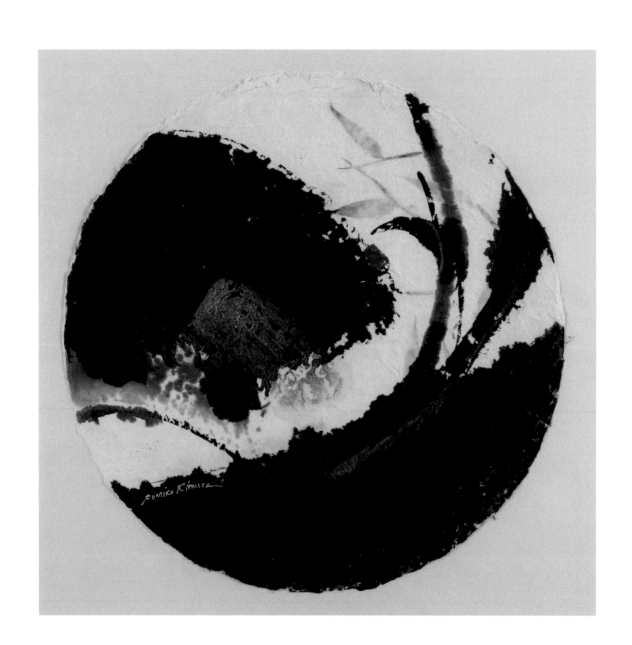

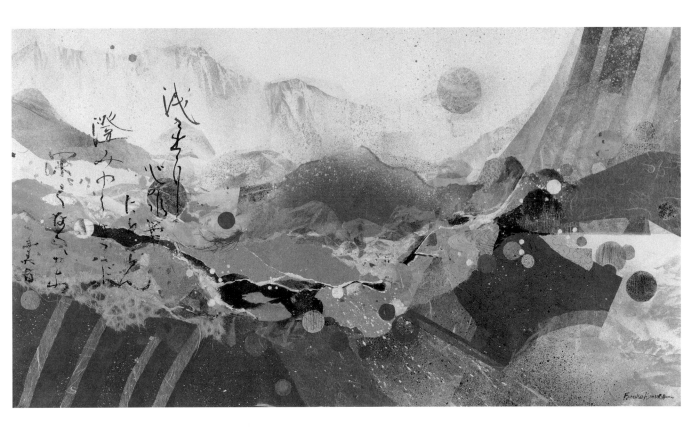

Opposite

Universe #2, early to mid-2000s, mixed media, ink, and artist-made paper, on paper, 12 × 12 inches. I wanted to create an enso-like form, that is, a Zen circle, with something inside. Mixed-media materials include gold leaf and bamboo leaves.

Water's Edge #2, circa 2010, collage and ink on paper, 21 × 36 inches. The poem is by Japanese poet Saigyō from the 12th-century. Very beautiful in the original Japanese, it translates:

The mind for truth
Begins like a stream, shallow
At first, but then
Adds more and more depth
While gaining greater clarity
(William R. LaFleur, trans.)

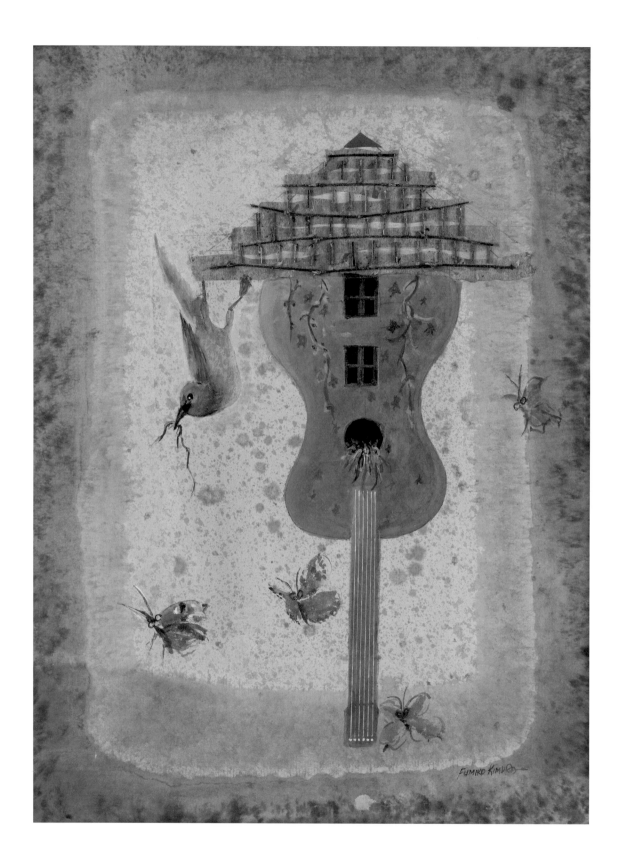

FUMIKO KIMURA

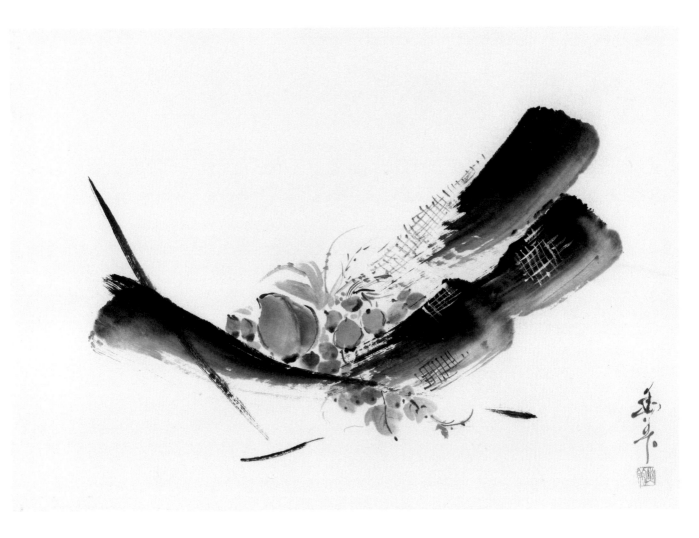

Opposite
Guitar Birdhouse, early 2000s, watercolor on paper, 18 × 10 inches. I wanted to make a sheltering house for birds and put a roof on the guitar.

Zen Basket, circa 2012, ink and watercolor on paper, 12½ × 18 inches

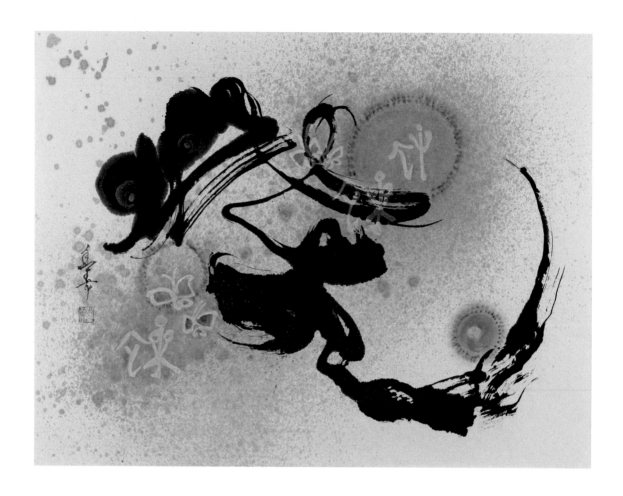

Butterfly, circa 2015, ink and watercolor on paper, 13 ×
16 inches. I had a good time imagining the character for
butterfly (painted in black) flying around like butterflies
do. This was one of a calligraphy series I think of as
combining East and West. Western components are the
background shapes and colors, and Eastern the trans-
formed calligraphy.

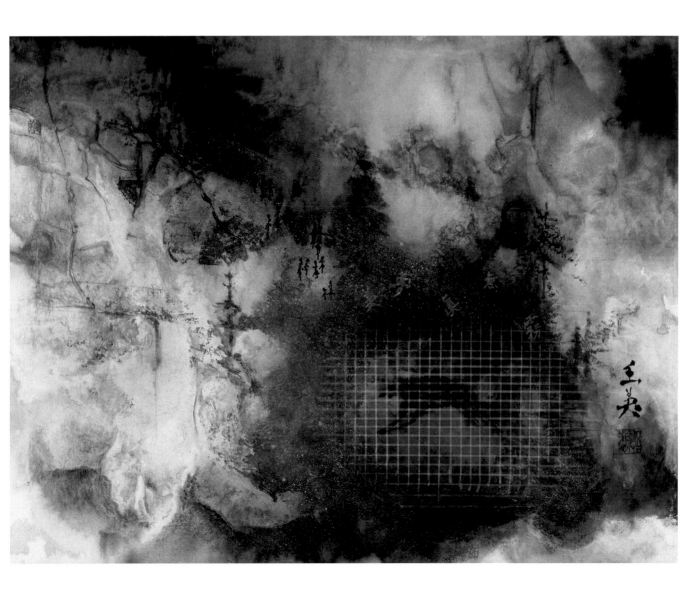

Irony, 2017, ink on paper, 19 × 25 inches. Lots of dark
and moody grays created by pouring ink. Animals can't
come to the city and can't be in the woods. Either way,
poor things, they're just confined. The six white charac-
ters above the "cage" are, from the left, beauty, dream,
truthfulness, beauty, nothingness (*mu*), and fog.

Size my paper w/ nikawa

I N. 1 ; 1 H₂O 50%

II N - 50% H₂O: take half of this +
add equal H₂O

III ½ II + add H₂O Equal amount

Will be back soon to see which ones
will work - Comments or less -

check out: enlarge spots in various shapes. Add some colors to central
area + bleed out. Bleeding is the deep total line as in rocks.

Li Huesheng

Wei Qi Xin

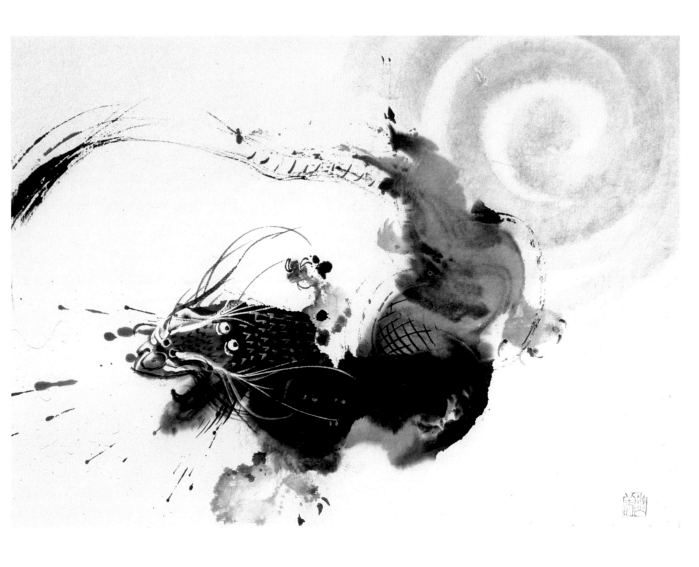

Opposite
Untitled, pen on paper, 2017,
8½ × 12 inches. I sometimes
plan artworks in a notebook,
like these thoughts for the
"One.Dot.Sumi" series.

Dragon, 2011, ink on paper,
12 × 18 inches

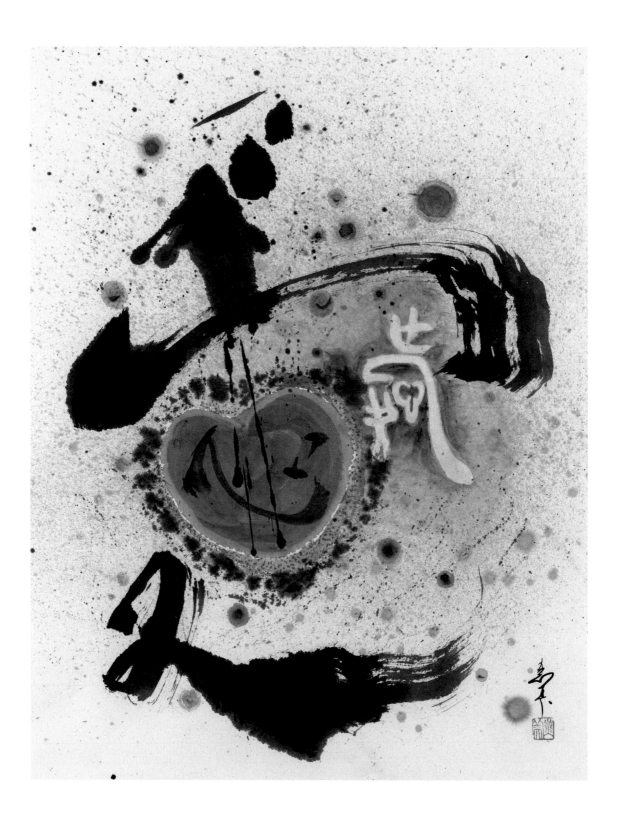

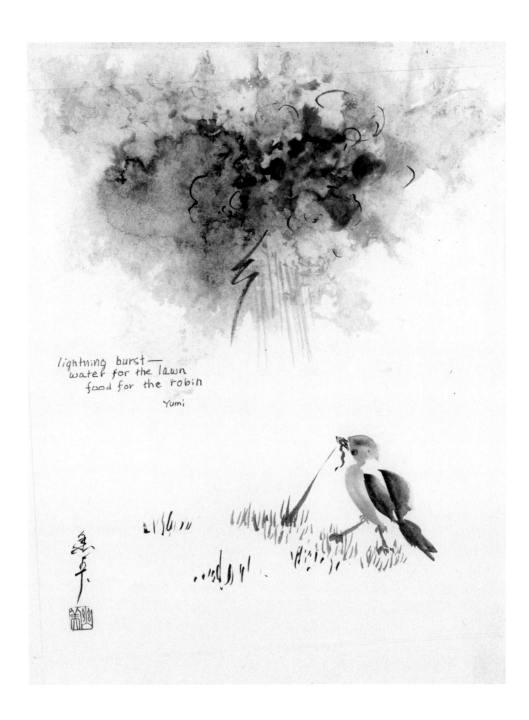

lightning burst—
water for the lawn
food for the robin

Yumi

Opposite

Love, circa 2015, ink and watercolor on paper, 16 × 13 inches. The central black character is *ai*, love, and the white character is inspired by an ancient pictogram with the same meaning.

Robin, 2016, ink on paper, 13 × 10 inches. Haiga is a traditional form of Japanese painting, a combination of image and word generally based on simple observations of the ordinary world. This was one of my first haiga with my own haiku. I saw a robin in my front yard and he just pulled the worm out.

Dots, 2017, ink on paper, 10 × 17 inches. These are my
friends, the ones I encounter on my walks. Last year
butterflies and grasshoppers were abundant in my back-
yard. They stopped right in front of me. What was that
all about?

A survey of artistic undertakings and critical themes from the 1960s to the present. Some of these efforts weave in and out of my career, though some, like collage making, are always present.

Collage and Paul Horiuchi

1960S–PRESENT

In the 1960s, as I was painting nature scenes when my family was asleep, I also began making collages. I loved making them. I recycled paper from my older sumi works, tearing, cutting, and coloring them, and combining with little images I painted on watercolor paper. I assembled everything with cornstarch glue made on the kitchen stove. I was inspired in part by the nonobjective painting that was popular around this time.

Typically there would be no subject or theme at the beginning; it was an almost random gluing of elements. This is still largely my process with collage, very intuitive. I collect and use old paper, dried flowers and leaves, little sticks. All kinds of items. Unfolded used tea bags with the tea leaves discarded are among my favorite found materials. The stained gauze is subtly colored, and I like recycling from ordinary life into art-making, and finding beauty in ordinary things.

At some point during the process, an idea for the subject matter suggests itself. This I develop, and then finish with brush and ink lines or a gold-leaf accent. I enjoy this type of process, mystery and unknown first, and clarity later.

My collage process has roots in viewing Paul Horiuchi's collage exhibit in the 1960s at an art gallery in downtown Tacoma. I was amazed how Mr. Horiuchi used subdued colored papers to create rhythmic,

Clearcut #1, circa 1967, ink on paper, 13 × 25 inches. This abstract piece was inspired by seeing a clearcut forest and smoldering slash piles. Artist Paul Horiuchi contacted me after he saw the painting on exhibition and we became friendly.

nonobjective shapes in a vast space. Mr. Horiuchi was a Japanese-American artist who became established in Seattle for his collages, an innovative fusion of East and West. Often he included Japanese words in hiragana or block-style calligraphy to enhance the movement or to stabilize the composition.

In 1967, Mr. Horiuchi saw one of my rather abstract sumi paintings at the Bellevue Art Museum, selected from the annual Bellevue Art Fair to exhibit at the museum. It was an early example of what developed into my "Clearcut" series, done with black ink. He called and invited me to view his solo exhibit at the Tacoma Art Museum and to have lunch with him and his wife, Bernie (Bernadette).

He said that he enjoyed viewing my piece at the Bellevue Museum and I should continue to paint sumi-e in that style. "Keep on working like that," he said. I wasn't sure what he meant, but as I look now at the ink painting he admired, I say to myself, "oh my gosh, so many sumi colors and textures, and so much energy." And I think that was what he saw that was important.

The Horiuchis invited me to come and see them whenever I was in Seattle. I would visit them on Saturdays when I taught class at Uwajimaya grocery store. I went to their waterfront home in Rainier Beach designed by architect Gregory Saito, and sat in his daylight basement studio. I listened to him talk about painting and life, and he

Colors and Patterns from Heian Period, Paul Horiuchi, 1969, casein and paint on paper mounted on board, 54 × 105 × ⅝ inches, collection Seattle Art Museum 71.52, gift in memory of Elizabeth A. Smithson by her son, Richard B. Smithson. Photo credit Elizabeth Mann.
Seattle artist Paul Horiuchi (1906–1999) was an influence on me. I admired his artwork and enjoyed talking with him about painting and life.

encouraged me to visit New York and get a feel for contemporary paintings. How fortunate that I was able to visit New York in 1989 and stay at a former student's home in Philadelphia. We commuted to New York by train. The Guggenheim Museum was impressive and I saw Helen Frankenthaler's giant color wash paintings, and also other exhibits of artists invited from Japan. Mr. Horiuchi was quite critical about galleries in Seattle, and he encouraged me to do my art for the joy of it. If you do that, he said, you will do well and never give up. His encouragement helped me to continue in the path of art making. We also communicated by mail. His letters were always written in Japanese, and I would write back in Japanese. I think he missed using the Japanese language. He was very interested in my trip to Senjuin Zen Temple. He never had that kind of opportunity, but he "lived" it in his collage paintings and in his daily life.

I love the collage process for its possibilities and ways of using materials. The field has great potential for expressing passion and personal style.

Opposite
Harmony in Nature, circa
1998, mixed media on paper,
17 × 13 inches. A collage made
with thin paper and unused
gauzy teabag material twisted
into threads.

Waterfall of the Mind 2, 2013, ink and
paper collage on paper, 16 × 13 inches.
The poem is by Saigyō, a 12th-century
Japanese poet, which I have used a few
times in my artworks. It translates as:

The mind for truth
Begins like a stream, shallow
At first, but then
Adds more and more depth
While gaining greater clarity
(William R. LaFleur, trans.)

Fumiko Kimura

Opposite
Dream of Freedom, 2014,
collage, ink, and paper cut-
outs on paper, 21 × 14 inches.
This piece was done for
a book, *Who is God: The
Collection* (Robert Ellison,
ed., GDPStudios, 2015).

Memories Collage, 2014–15,
ink and paper on silk, 14 ×
11 inches

Tacoma City Ballet

1993–1997

In 1993, for the Tacoma City Ballet, I painted a 17-foot-high by 18-foot-wide backdrop, sewing white sheets together to serve as "paper." I used a broom to make abstract calligraphy-like brushstrokes accented with silver. I worked with the ballet for four years until 1997, creating backgrounds and sets. One time I designed tree trunks of white butcher paper over a wire frame, painting them with sumi and suspending the forms from the ceiling as a forest. Another time, I painted colorful abstract lines on the leotards of every dancer in the troupe, more than twenty. I love the atmosphere and energy of the ballet.

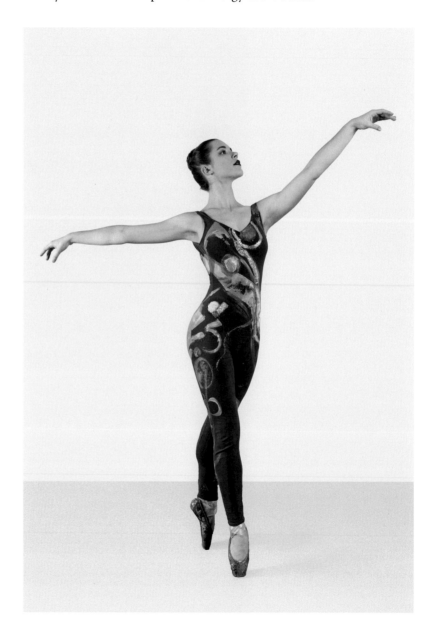

Untitled, acrylic paint on leotards, 1993. I painted leotards for a Tacoma City Ballet performance titled "Renewal," inspired by the Los Angeles riots. I painted the entire company while they wore the leotards, more than twenty dancers.

Opposite
Making sets for the Tacoma City Ballet, circa 1995

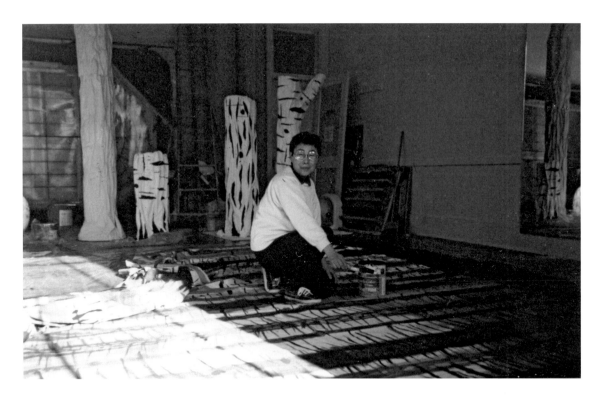

Clearcut Series

1990–CIRCA 2000

I traveled with my family to the Pacific Ocean many times, camping out in the early years. One time on my way to Cannon Beach in Oregon I saw a clearcut forest. The debris piles were still smoldering. I felt like a distraught bird, frightened, angry, and confused. I had come across scenes like this before, as Yosh and I liked to go mushrooming, especially with my brother George. I had also seen great stacks of lumber ready to export and, on television, majestic expanses of forests toppled. My heart ached viewing scenes like these and I would close my eyes.

These experiences prompted me to create a series about forests culminating in an exhibit in 1995, called "Harmony in Conflict: Forest Phoenix," at the Washington State History Museum, the state's history museum. I depicted felled individual trees with abstract swaths of black ink and sometimes a bit of color. I poured my feelings for trees into these pieces. The early ones were representational, sometimes expressionistic and other times with delicate brushstrokes, soft washes, and little creatures. Later ones became more abstract, the felled trees depicted as bold swoops, a confusion of blotches and dots flying about, the trunks occasionally suggesting human torsos writhing "like a bull gored in the ring," as one reviewer put it. But still, there is hope and renewal even with destruction, and I usually incorporated new growth and young forests in the background.

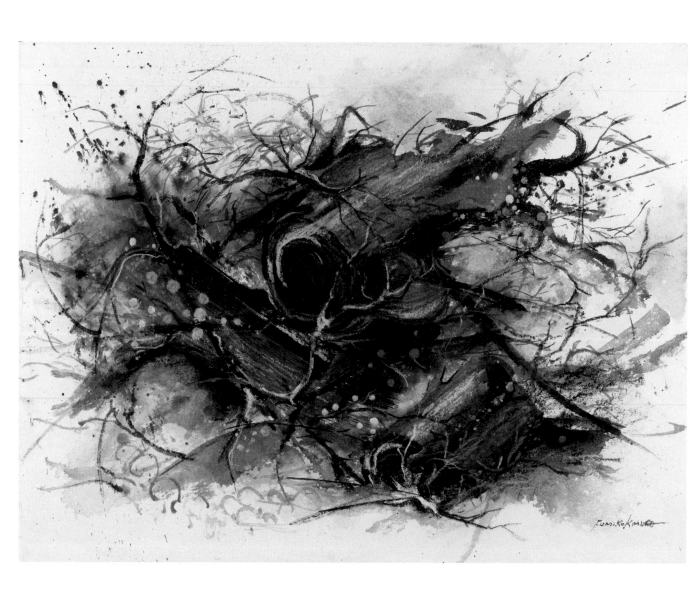

Deforestation ("Clearcut" series),
1995, ink, watercolor, and pastel
on paper, 18½ × 22½ inches

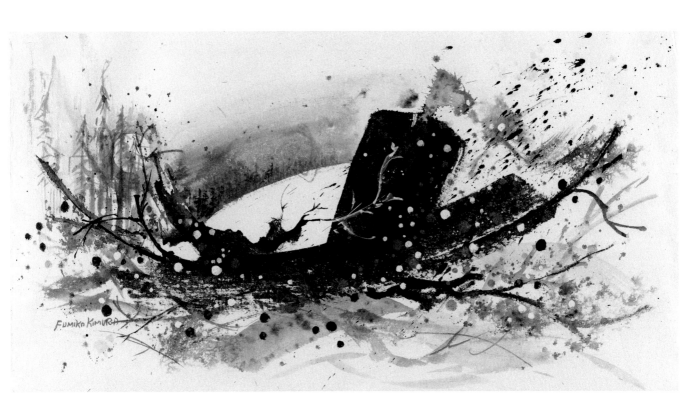

Untitled ("Clearcut" series),
circa 1994–95, ink and water-
color on paper, 13 × 26 inches

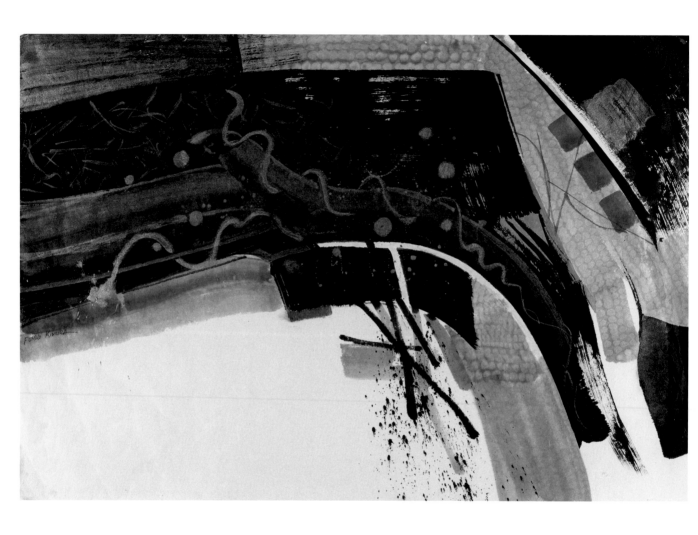

Abstract Clearcut ("Clearcut"
series), circa 1996–97, ink and
watercolor on paper, 26 ×
37 inches

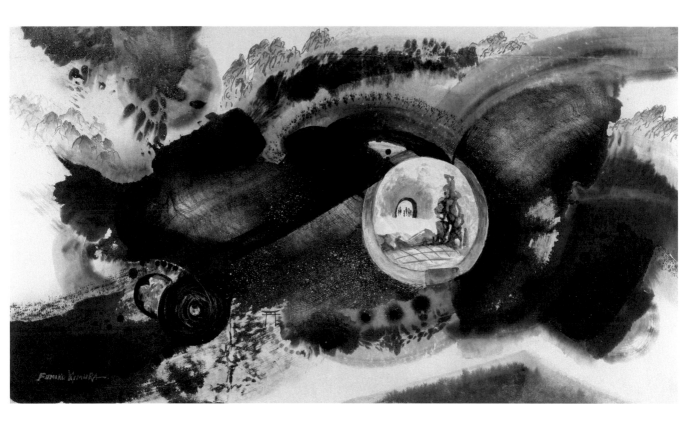

Journey to Shangri-La, mid- to late
1990s, ink on paper, 21 × 38 inches.
I sometimes added gates or portals
to "Clearcut"-related compositions.
I'd dream about ending up on the
other side of the gate someday.

In one composition, I showed a tree stripped of branches, just a trunk, wearing a kimono. I thought it needed something to keep it warm in the coming winter. While such thoughts and stories were running through my head as I composed, most of the works themselves are restrained, tamed as it were by the demands of artmaking. The pieces are designs of lines and colors first, not howls. Sometimes they developed into just arrangements of shape and color, fully abstract. And philosophically, I took the long view. All things change and nature recycles.

The dots flying about were added for formal and texture purposes, and are not generally speaking debris. But they could be considered micro water dots or vapor enlarged to visibility—water is always around us. Perhaps they could be considered as *ki*, a Japanese word broad in meaning, invoking energy, air, spirit, and vapor, as well as expansive ideas of creative flow and inspiration (*cf.* Chinese, *qi*).

As the "Clearcut" motif further evolved over the years, I sometimes inserted a gateway, typically round. A symbol of entrance to the other side, whatever that might be. A gate or portal to a Shangri-la where I'd like to end up.

"Painting in Sumi, Stroke on Stroke: A Guide for Beginners"
1997

All the time I was painting I was also teaching, and in 1997, at the urging of my students, I published *Painting in Sumi, Stroke on Stroke: A Guide for Beginners*, with support from the Tacoma Arts Commission. The book emphasized fundamentals of how to shape brushstrokes, paint with lines and dots, and so on, and was illustrated with images from the natural world of the Pacific Northwest. The book described an approach to painting "that flows from the depth of soul in an inexplicably controlled free-hand style." That loose style is not haphazard but requires study and preparation for realization. As I wrote:

> It is of importance to carefully observe the subject matter and to reinforce this observation by pencil or brush sketching. In short, a thorough knowledge and visualization of the structure before painting the subject in strokes are critical. The artist, then, inwardly contemplates the subject for a while to create a mental image before commencing with the actual painting. By mastering the basic techniques through disciplined and frequent practice, the artist is liberated from the step-by-step learning to the point where the flow of the brushstroke becomes instinctive.

Opposite
A page from my book providing a beginner's guide to sumi painting.

Mouse

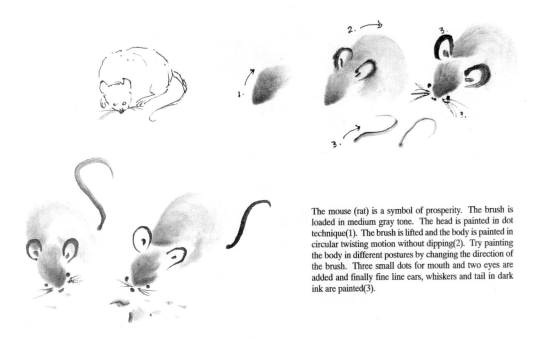

The mouse (rat) is a symbol of prosperity. The brush is loaded in medium gray tone. The head is painted in dot technique(1). The brush is lifted and the body is painted in circular twisting motion without dipping(2). Try painting the body in different postures by changing the direction of the brush. Three small dots for mouth and two eyes are added and finally fine line ears, whiskers and tail in dark ink are painted(3).

Enso Painting, Wabi-Sabi, White Space

Circles appear throughout my artwork and in various forms: as blobs, dots, outlines, and so on. They are a significant motif for me. Circles have many meanings. Most directly, they suggest the sun or moon. I included such circles even in my earliest works. They help create a landscape, but also establish a detached context for the viewer. So, for example, in many of my "Clearcut" pieces, there is the drama of the felled tree, but also the soothing balm of a quiet moon or distant sun.

Another circle is the Japanese *enso* practiced by Zen monks. Enso is a circle drawn with brush and ink in one fluid stroke. It represents the way of Zen. Brushstokes can be thin or thick, solid or broken, full of energy or restrained. Meanings of the enso are many: symbol of Zen insight, emptiness or everything, and also ideas of connectedness, fulfillment, harmony as well as simplicity and Japanese minimal aesthetics. It is at once symbolic and literal. Inspired by the Zen monks' requirement of enso studies, I began using the brush to find the energy of arm and hand, and to feel connections between my body and internal feelings. My choice with enso was not the traditional one, but to explore the form in combination with representational images. In other words, I was using the traditional enso to help make a painting. I was reassured

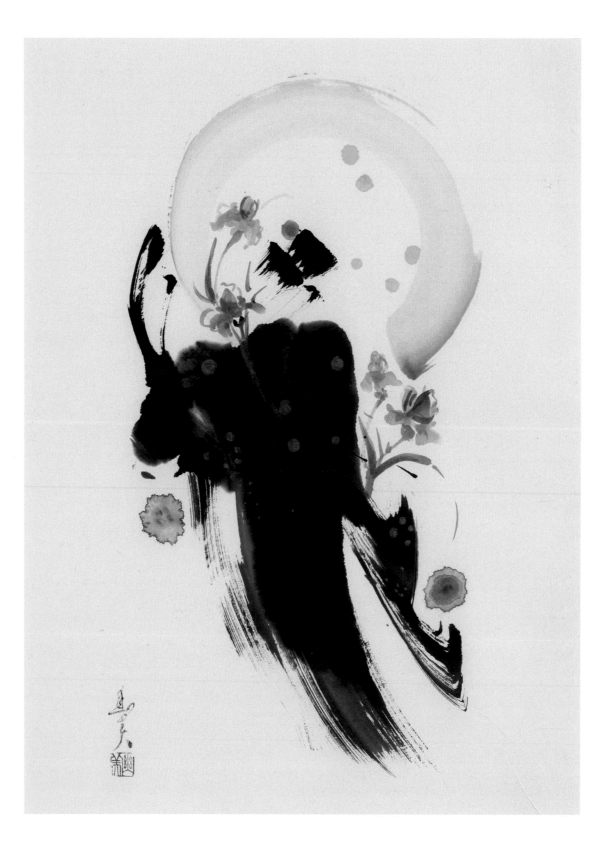

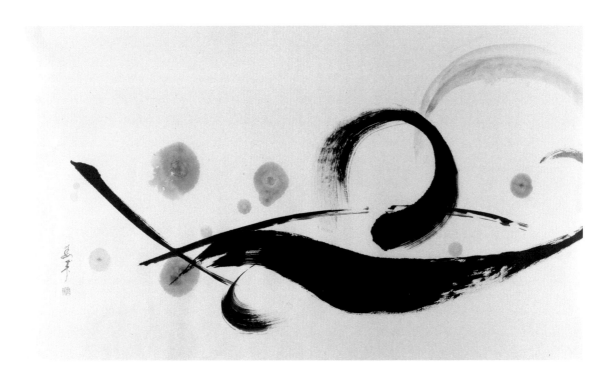

Pacific Sunset 2, 2018, ink and watercolor on paper, 20 × 34 inches. I did a number of paintings using linear brush movement suggesting land-scape, both large and small, from around 2010 to 2018.

Opposite
Flowers of My Heart #2, circa 2010, ink and watercolor on paper, 15 × 12 inches. An enso form with flowers and dots. Dots are like *ki* to me (Chinese, *qi*), which is spirit, breath, air, energy, all those things. Water vapor too.

how the enso connected to other forms and the tangible world of flowers and landscape.

Wabi-sabi is another aspect of Japanese aesthetics that I have pursued from time to time. Wabi-sabi, like *ki*, is expansive and hard to define. It embraces the idea that the world is impermanent; that things change, age, and decay, and that there is beauty in the forms that express this impermanence. It has to do with natural simplicity. I have used found objects like leaves or bark, and pieces of worn paper, to make clean assemblages to explore this quality. I have also pursued wabi-sabi through a more Western lens as well, for example in my representational watercolors in the 1950s and 60s. I saw battered metal garbage cans in an alley in Tacoma. They were crooked and rusty, but still being used. I recognized a beauty there. I painted them using watercolors on water-color paper, and, influenced by the American watercolorist John Marin, emphasized angularity in even the clouds (see *WabiSabi*, page 43).

Wabi-sabi is a far different idea from what we usually celebrate in the West as important or beautiful. It is a Japanese aesthetic that has spread around the world and been variously interpreted. In my mind it references deep humble feelings for things that are old, and relates to apology in some curious way. Things have a long history, they flourish, and then they are crumbling. There's a sadness that things have to be that way.

116 *Apology*, 2018, mixed media assemblage with bark on board, 18 × 11 inches. Part of a series of three-dimensional work inspired by thinking about wabi-sabi, the idea that things decay and age, and that there is beauty in that process.

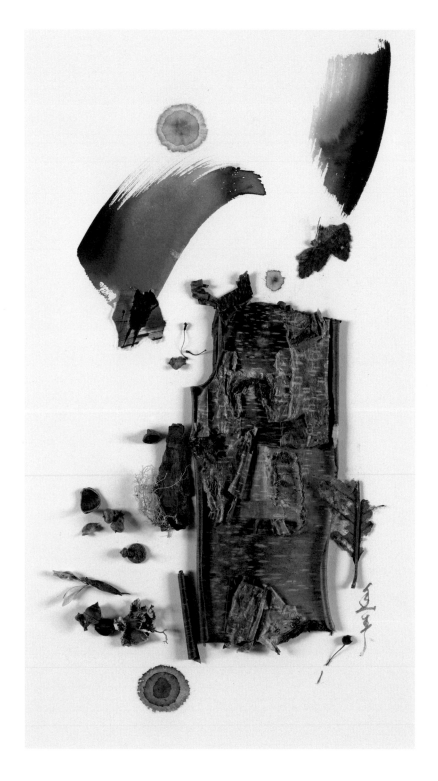

Another Japanese concept of interest to me is called *ma*, an architectural term meaning space, the intervals between things, and more generally the idea of emptiness. From an artist's point of view, this can be as simple as an uncluttered composition with plenty of white space on the paper. This helps create simplicity and calmness. In the modern Sogetsu School of Ikebana the founder said, "Ikebana is an art of space, the space between branches, flowers and leaves. This space is a plentiful void projecting tension and energy." The "plentiful void" makes a springboard for artistic creation. Artworks embracing *ma* also can be thought of as embodying tenants of Buddhism and Taoism, the simultaneous experience of form and no form, and thus lending a metaphorical or even metaphysical dimension.

There is a rule of thumb in sumi art about leaving a majority of empty space, that is, much unpainted paper, but I have struggled with so much whiteness. For me, blank white space can be too severe, too cold. Often I add a light wash near the subject, letting it fade toward the edge of the paper. The subject exists in an atmosphere, an aura of color that is reflected from the subject matter, be it pine tree, or plum blossoms, or whatever. I imagine . . . I feel it . . . I almost see it, so subtle. I tell myself, "Go ahead and add the green-blue, or soft purplish wash . . . and let it fade into the white space."

Really, I think of myself as a colorist, whether using hues of the rainbow or black and gray. I depend on colors to express the subject/object relationship. Color is more powerful than any language I can use, and touches the emotion of both artist and viewer.

Untitled study, early 1980s, watercolor on paper, 15 × 24 inches. I was experimenting with running different color washes through a printing press.

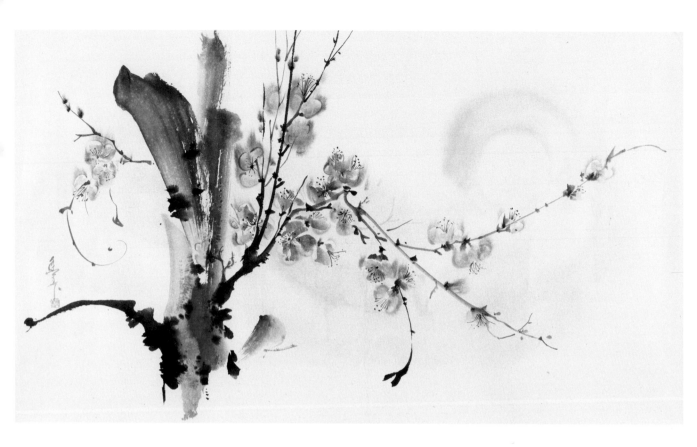

Color and "Enduring Dao"
1998–PRESENT

In my early years and for many decades as an artist I favored soft lavenders, purples, and greens in my paintings and collages. Cool, soft colors. Once Jeanne, my daughter, when she was 7 or 8 years old, told me, "Mom, you look like lavender color." Another time she mentioned I looked "purplish."

I certainly embraced those colors and avoided red. Red reminded me of my dress catching fire when I was ten years old, lighting the kerosene stove while Mother was out in the fields. When I recall that day, I can still feel the scorching heat on my body.

I associated red not only with fire and pain, burns and scars, but also with emotions like fear, shame, and guilt. Four months in hospital, disfigured skin, and years of Father telling me that I was a freak made an impact. I didn't speak or write to my father after this childhood incident except for perfunctory words. He was walled off in my mind. I guess that was to protect myself from feelings of rejection. Even after he died I didn't wear red clothes or use red in my artworks. If I needed the warmth or brightness of that color for a composition, I added yellow, blue, or brown to it to subdue the intensity.

Opposite
Cherry Blossom, circa 2004–
2005, ink and watercolor
on paper, 22 × 38 inches. A
traditional subject made with
black ink and various shades
of gray—the beautiful colors of
sumi. Sometimes the negative
spaces that sumi emphasizes
seem too vacant and cold,
and I use a wash to augment
and suggest instead of leaving
the paper bare white.

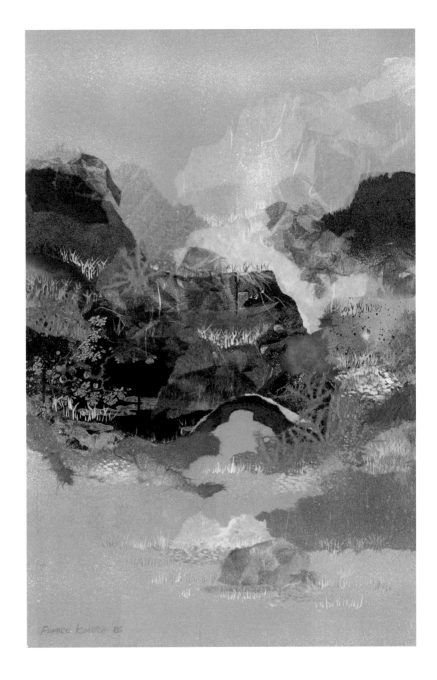

*Buried Echoes of Autumn
Wind*, 1986, collage on paper,
19 × 13 inches

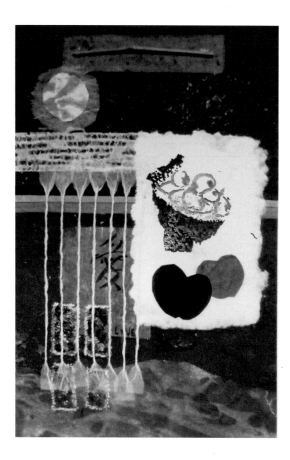

Love, circa 1999, mixed media collage on paper, 17 × 13 inches. Part of the "Enduring Dao" series, in which I started using red as an important or predominate color.

Off and on throughout my life I have confronted this difficult father-daughter relationship. Such a problem. We carry our parents in our heads. One day in 1998, when I was sixty-nine, I suddenly felt the need for an "atonement process" in regards to my father, which I had learned about in Bible class at my church, the Whitney Memorial Methodist. It was a Christian process to "forgive myself" as "I forgive the other person" in a conflict situation. The sensation occurred so suddenly it was frightening. I did not know what was happening and was crying profusely. I finally called the church and the minister invited me to come over. I drove there and started to sob again. After talking things over, I calmed down and returned home with a huge load off my mind. After that, I began exploring the color red in my collages without fear or dislike of the color. I wondered, "What if I use mostly red in a composition?"

I began a collage series staining the paper bright red, adding torn paper and other collage elements including thin sticks of bamboo. I used shapes found in the city skyline and patterns observed in my daily walks. For a final step I added a haiku poem or Asian calligraphy. Each collage came to a final stage of development, and I gave a title. The works had brightness and warmth; they were relaxed, balanced, and I think of them as having spiritual implications and expressive cosmic energy. It was the first time I had used vibrant red, and I found out how much fun that can be.

Painting and making collages using red this way was a healing time. The color red evolved into new meanings for me, of love, passion, strength, peace, and determination to keep my life moving forward. I call these series of artworks "Enduring Dao," where dao is the path, the passage from one point to another. Many times in my life I have had to make a hard journey or transformation. None was harder than trying to reconcile with my verbally abusive father. I have realized the harder the emotional difficulty, the deeper the understanding that comes when resolved, as I am more at peace and have deeper love for my family, friends and other sentient beings. I am passionate about my life in painting to express the beauty of color and other creative dimensions. I have

Untitled, 2015, ink, water-
color, and paper collage,
14 × 12 inches

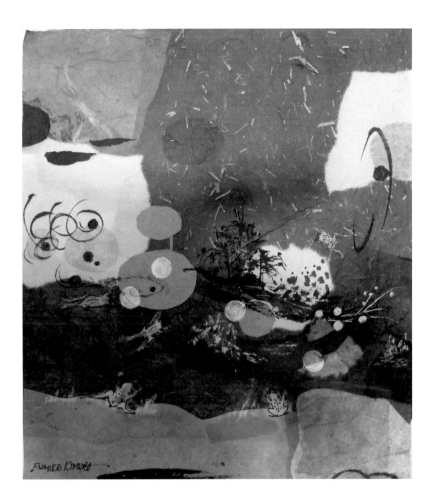

this passion and compassion, and I want to continue. I think that it comes from overcoming difficulties. It is the opposite of my attitude in the beginning, when I was afraid. Now I am wide open.

Nonobjectivity, Abstraction, and Monte Morrison

1975–PRESENT

Monte Morrison was one of my teachers at University of Puget Sound when I began my masters in art education, at age forty-five, and he pushed me towards abstraction from a Western point of view. He was an abstract painter who made his own pigments and built his painting surfaces by laminating acrylic films and substrates as one might construct a collage. He usually did not finish his paintings. His idea was that the viewers bring their own thoughts to complete the composition. A posthumous exhibit noted Monte was fascinated by the revelations of modern physics; the notion of an unknowable essence in our universe emphasized for him the importance of process. As the exhibit essay said, Monte for the most part rejected the idea of a final, finished product

and "had faith that the pursuit of art, as either artist or observer, has the potential to create a 'metaphoric mind state,' through which an individual may achieve ultimate growth and development."

Monte believed in abstraction, and abstraction is a rich idea, including both completely nonobjective imagery and simplification or transformation based on some subject matter. In practice, for the artist, and as experienced by the viewer, these divisions are rather permeable. There are so many ways to search and develop, and establish meaning. In the West, abstraction evolved around the turn of the last century, and was linked with reaching beyond the observable world to reveal hidden realities by such artists as Hilma af Klint, Piet Mondrian, and Wassily Kandinsky. Monte came of age at a time when abstraction, via Abstract Expressionism in America and Lyrical Abstraction in Europe, was not only well-accepted but ascendant, a seemingly purer artistic endeavor linked to idealism, revelations of the unconscious, and transcendence.

I used the examples of these artists, Monte's ideas, and those of Mokusen Saito, in my classes when students were disappointed when their colors or shapes did not turn out as planned. It is not a mistake if painted from the heart intuitively, I would say. The approach frees many students from overbearing rules and inhibitions. As a teacher it is a joy to find students becoming liberated and working with freedom.

I talked with Monte all the time. We liked to critique each others work and share our thoughts. He wanted my opinion on this and that. He evolved from a teacher to a mentor to a colleague and deep friend, a solace after my son died and an intellectual companion. In my diary from May 1981, I wrote he is "a soul mate who has to be an integral part of my intellect. . . . His soul is so gentle and it flows into mine ever so gently and it's soothing. I can be my total self."

Negotiating all this while maintaining my marriage and family wasn't easy. I was a mature woman with no desire for disruptions. But I found my relationship with Monte flattering and fulfilling.

Monte had some personal problems and took early retirement from University of Puget Sound under murky circumstances. He then taught at Tacoma Community College. I continued to take classes from him there, including figure drawing, even while I was teaching my own classes, and making and selling paintings. It was a way to keep learning. In 1997 he had a fatal one-person accident while driving in the countryside near Gig Harbor. It was a big loss for me. The end of a twenty-year friendship. Could it have been suicide? The last day of the school year, he had hugged me, to say good-bye. He never hugged me. I was surprised. But I think he was saying good-bye.

Opposite
Shadow Play, circa 1996–97, ink and watercolor on paper, 23 × 13 inches. An extension of the "Clearcut" series into pure abstraction.

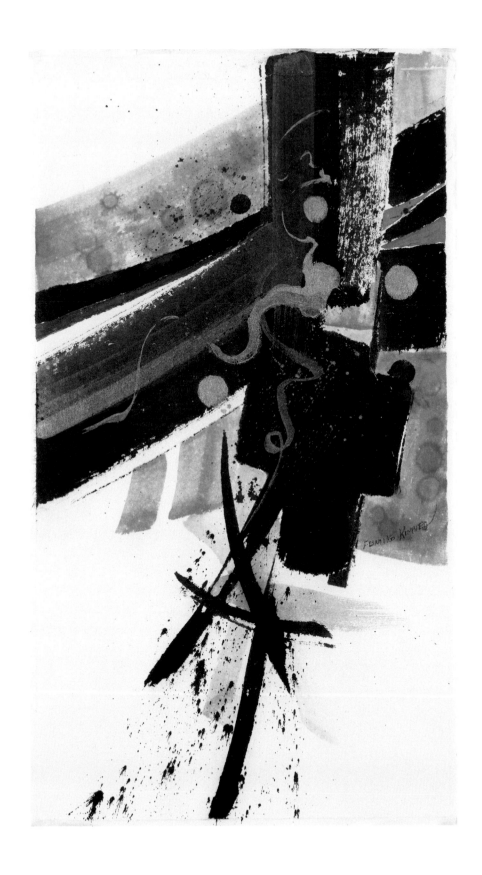

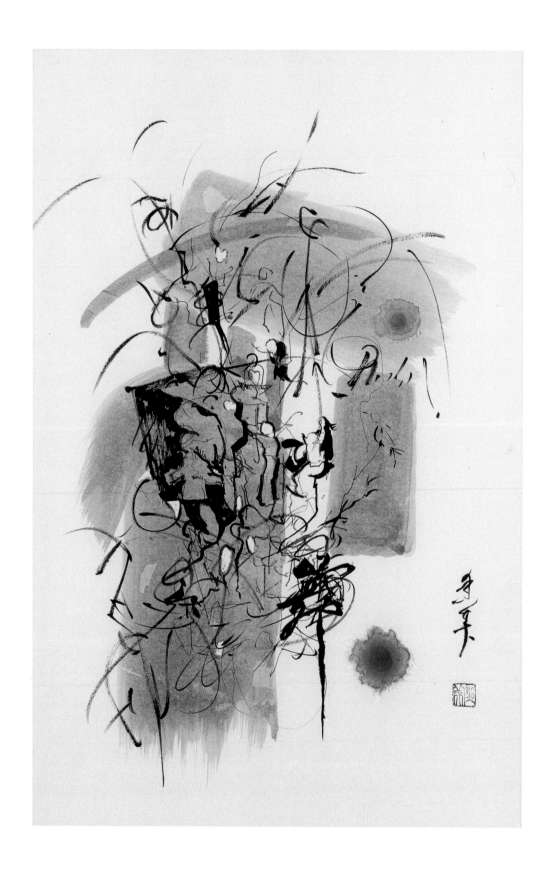

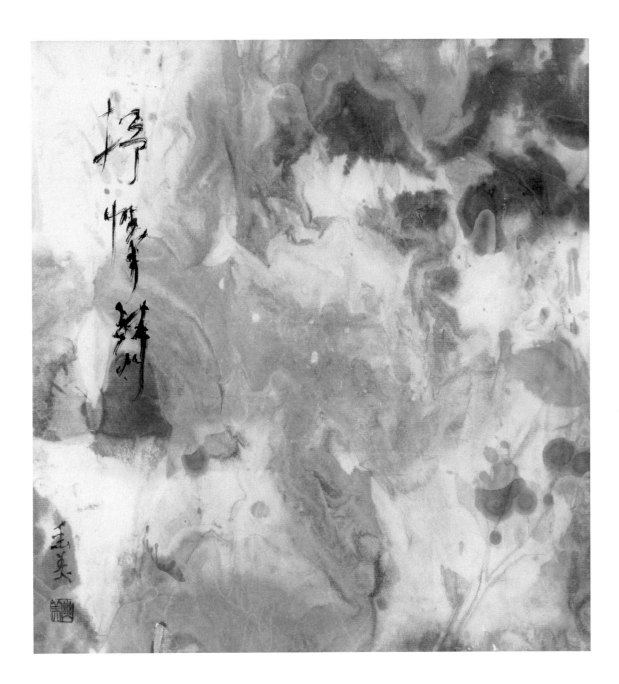

Opposite
Untitled, 2018, ink and tea
on paper, 15½ × 10½ inches.
I went to rehearsal at the
Tacoma City Ballet and made
these gestural sketches. The
wash is ordinary tea, which
makes a warm, translucent
color.

Lyrical Poetry, circa 2016, ink on paper,
13 × 12 inches. I sometimes pour or
otherwise apply ink without a brush, a
technique called Po Mo, or splash ink,
and work with the resultant imagery. Here
I added the Japanese words for lyricism,
or lyrical poetry, to the top left.

Haiga, Words, and Calligraphy

I have always enjoyed poems even as a young girl, and have often added poems to my artwork, written in Japanese or English. It adds another level of meaning. In Japan, the combination of haiku poem and image in a painting is called haiga. Words and image interrelate, but one is not illustrative of the other.

> in spring
>
> frogs sing
>
> in summer
>
> they bark

I included that haiku poem by Uejima Onitsura (1661–1738), a contemporary of Bashō, in a haiga collage of 1987–88 titled *Frog Recites*. There's a small frog surrounded by dark blue and purple colors.

I do like to include a frog or two in my compositions from time to time. I identify with them, as a loner myself living in a pond, not knowing much of the wider, surrounding world. I do not travel much, but still, I have a life appropriate for me and am content. I admire frogs as they croak as if "reciting poems." I envy frogs as they can swim as well as hop with ease. I have not swum in all my life.

By adding words the viewer's imagination is stimulated, and there is intellectual enrichment. The look of words also enhances and complements the design. I feel the haiga tradition has been underappreciated in the United States. In 2012, following a talk by Sam Hamill, a poet and translator of Japanese poetry, Puget Sound Sumi Artists started a study group, Haiga Adventure, initiated by myself and Voski Sprague, to explore haiga and haiku poetry, and the interplay of image and word. The group meets monthly to discuss haiku poems and haiga images, and to paint.

One can hardly discuss sumi painting without addressing calligraphy, the Asian art form whose brushstrokes overlap with those of sumi painting. Words and poems created with the brush, that is, calligraphy, are beautiful in their own right, and I love transforming them in expressive ways. The character for "dragon" is one I have played with many times over the years, altering the shape to express an action or feeling. Dragons, considered mostly benevolent creatures in Japan, have power to control water. When the earth is thirsty, dragons cause thunder and bring rain. Their actions engender lightning as well, which can break down nitrogen in the atmosphere to produce plant fertilizer, another positive thing. Dragons are a symbol of strength, power, and good luck given to worthy people. I like to imagine dragons in the sky, ascending,

Opposite
Frog Recites, 1987–88, collage and ink on paper, 20 × 16 inches. There are a couple of frog poems in the composition, including the well-known poem *in spring / frogs sing / in summer / they bark* by haiku poet Uejima Onitsura (1661–1738), a contemporary of Bashō. The other poem reads *placing his hands on the ground / the frog respectfully recites / his poem* by Yamazaki Sokan (R. H. Blyth, trans.).

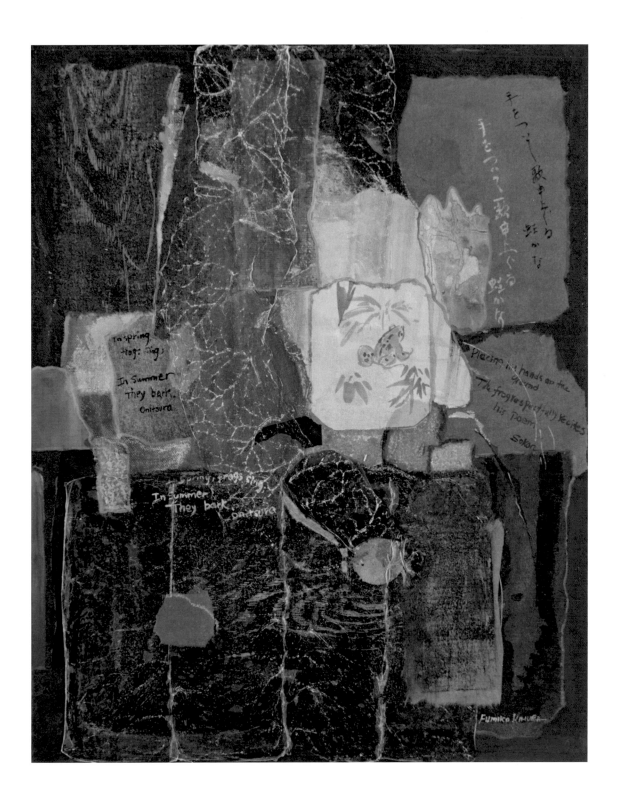

手をついて歌申しあぐる蛙かな

手をついて歌申しあぐる蛙かな

In spring
frogs sing;

In summer
They bark.
Onitsura

Placing his hands on the
ground
The frog respectfully recites
his poem
Sokan

Spring frogs sing,
In summer
They bark.
Onitsura

Fumiko Kimura

descending, and roaming about, and create calligraphy that parallels and embodies those movements.

In single-word calligraphies the word selected is naturally important, and I've been inspired to choose such words as patience, compassion, and excellence. I was already distorting and changing characters to reflect my vision when we formed our calligraphy study group in the early 1980s and invited a teacher from Japan, Mr. Misao Aoki. He said to us, "In each calligraphic work, you will find poems and dreams and hear music without sound using the kanji character that means deeply to the artist." Three decades later I did a series of English words in an Asian calligraphic style, and hoped to imbue them with "music without sound." I painted them for the annual international invitational calligraphy exhibitions at the Tokyo National Art Gallery, and in 2012 was fortunate enough to be recognized with an award that certified me to be an official judge of calligraphy (see *Excellence*, page 132).

I also enjoy incorporating asemic writing into my artworks, that is to say, marks and lines that resemble writing but have no actual meaning. You look at them instead of reading them. It is the form or suggestion of meaningful text. Such scribbles, gestures, and lines can add a special resonance. Though the term asemic writing is of recent coinage, ancient Chinese calligraphers often indulged in exaggerated scripts that no one could actually read, and these were appreciated not for their meaning but for their vitality and fluidity.

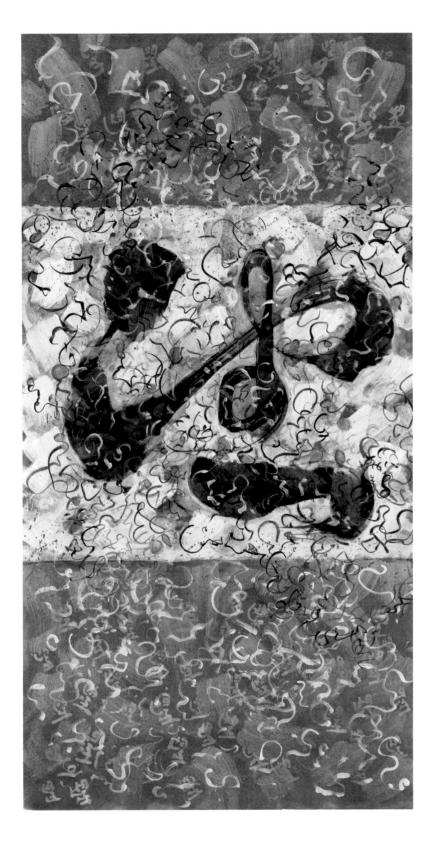

Wave, mid- to late 1990s, ink and watercolor on paper, 30 × 16 inches

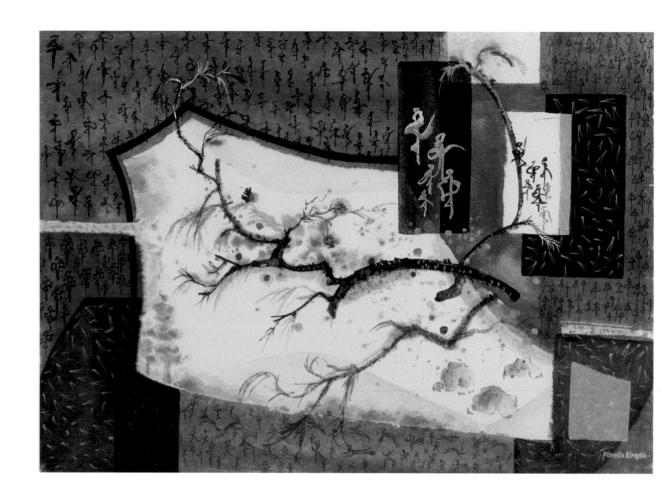

Deforestation 2 ("Clearcut" series), circa 1994–95, ink and watercolor on paper, 13 × 21 inches. Although the markings look like calligraphy, they are really just suggestive squiggles partially inspired by ballerinas.

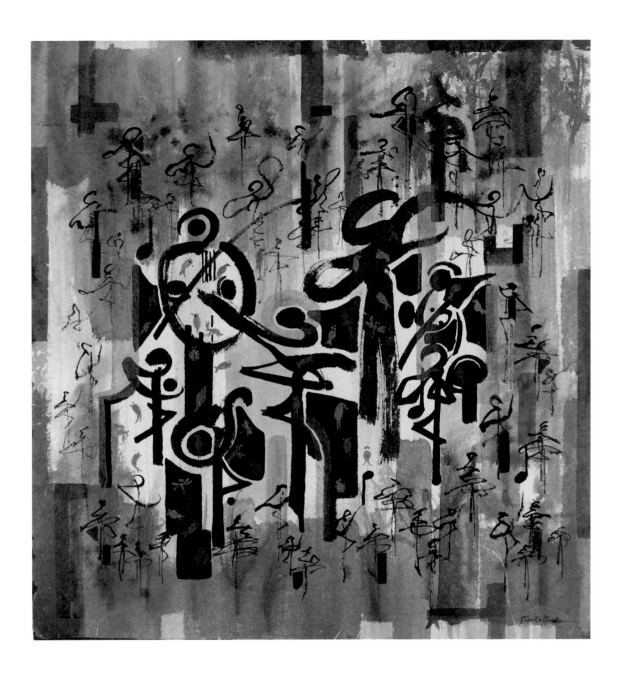

Forest Festival, 2000–2001, ink
and watercolor on paper, 25 ×
24 inches

132 *Excellence*, 2016, ink on paper, 27 × 26½ inches. One of a series of English words written as Asian-style calligraphy. I created these over a number of years for the annual invitational international calligraphy exhibit at the Tokyo National Art Gallery. In 2012, at their 25th anniversary exhibit, I received an award that authorized me to be a judge of calligraphy.

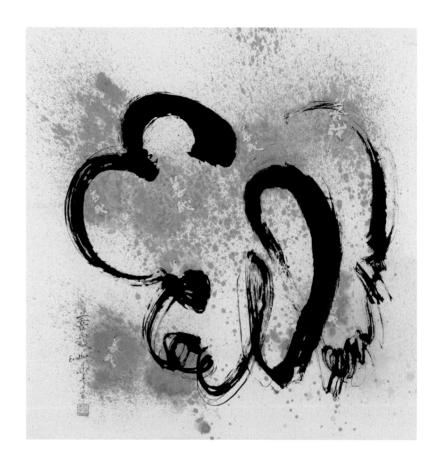

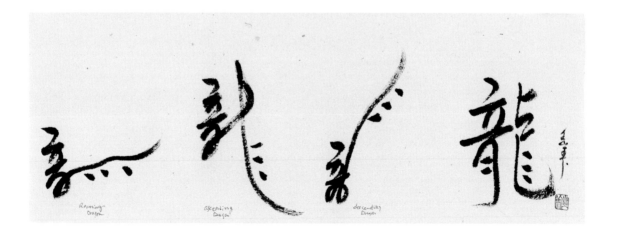

Ascending Dragon, 2018, ink on paper, 7 × 19 inches. From right to left, typical block kanji for dragon, and then my interpretation for descending, ascending, and roaming dragon using a semi-cursive or running style.

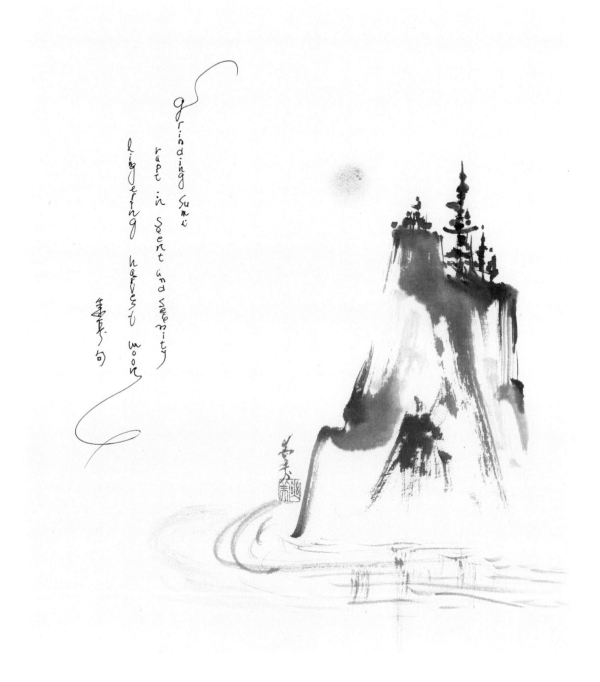

Grinding Sumi, 2018, ink on paper, 15 × 12½ inches. The poem,
written in English, reads: *grinding sumi / rapt in scent and
serenity / lingering harvest moon.*

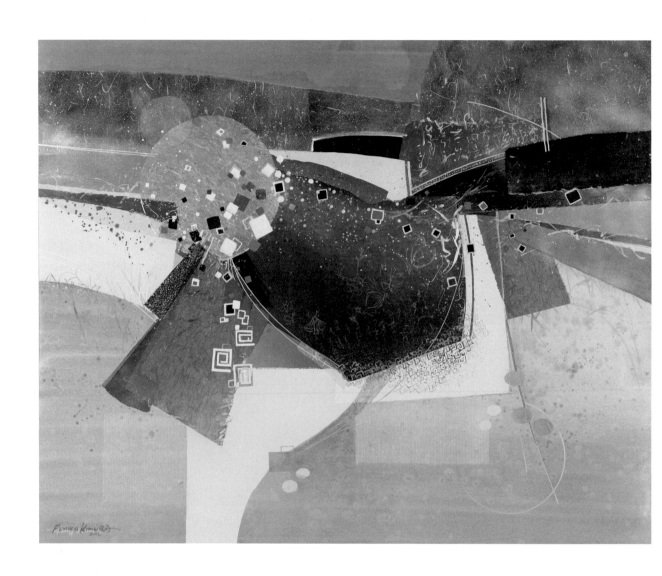

Alchemy of the Enduring Dao, begun 1980, acrylic and collage on canvas, 47 × 60 inches. I started this painting after my son's suicide. It will be complete with the addition of a haiku or some words. It's almost done.

Ray's Painting
1980–PRESENT

I mentioned I started an abstract painting with collage elements after Ray's suicide in 1980, so I could record my thoughts as they developed, a kind of diary for Ray's benefit. I put the painting away for years at a time, going back to add a touch now and again. The painting, 4-feet-tall and 5-feet-wide, includes many of my themes and subjects: gently overlapping rectangular and circular shapes in shallow space, little butterflies, a blizzard of tiny dots and squares, Japanese characters and pictograms or at least scribbles that look like those, and a palette of soft grays and purples. There is a title, *Alchemy of the Enduring Dao*, and though I signed and dated the painting in 2012, it is still incomplete. There is a space in the center where I want to add some words or poem, in Japanese or English. I don't know yet. But adding some words, for sure. That will complete the painting after more than thirty-nine years.

One.Dot.Sumi
2017

I've been using dots, blobs, and circles in my artworks almost from the beginning. They are motifs rich with suggestion and personal meanings. They engage the viewer and can be a surprise element. Circles can appear as the sun or moon, as an enso, or simply as a geometric element. But often, maybe mostly, I think of them as related to cosmic energy. In 2017, at age eighty-seven, I had a solo exhibit at the Kittridge Gallery, University of Puget Sound, titled "One.Dot.Sumi," using a spreading-dot technique on absorbent paper.

Sometimes I added three circles to the compositions, sometimes two, but never one, as one would suggest a sun or moon and I didn't want any such references. To create the circles I added drops of water and ink to paper where they would freely spread. My chemistry background occasionally offers the chance to combine art and science. For this series, I set up my kitchen as a laboratory to explore the best way to control the size and appearance of the circles, that is, the spreading dots. I mixed different concentrations of resist products to understand how they controlled the expansion of water and ink on the thin rice paper. This really was a kind of chemistry experiment as the water, resist, and ink operate at the molecular level. Tremendous forces are at work in the migration and bleeding of the ink. I tested solutions at different concentrations using gum arabic and Nikawa (a traditional Japanese animal-based binder/glue) and made careful records of the resulting effects.

I used rainwater gathered in a bowl during storms, and kept the water in a small bottle in the refrigerator. I wanted that connection to the natural world. The purity of the water was critical. It suggested other kinds of purity, of behavior and of the soul. Once I ascertained the effect

and control I wanted, I made the dots. First I spread a precise amount of the resist solution and let it dry. Then I applied a small amount of rainwater followed by sumi ink, freshly ground on a suzuri stone given to me by Mokusen Saito. This was repeated drop by drop until the desired effect and size of the circle was achieved.

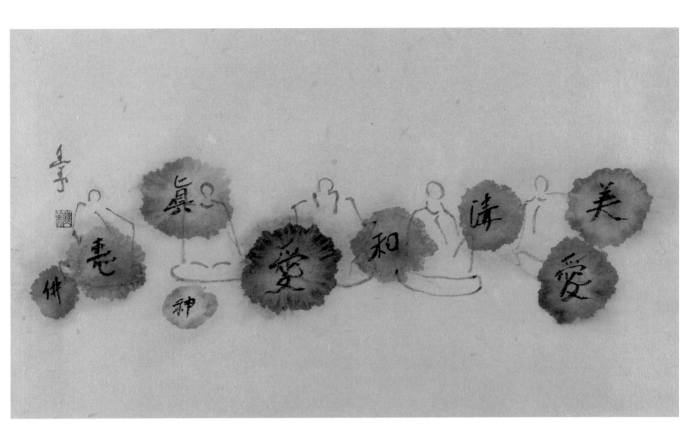

One Dot Sumi, 2017, ink and watercolor on paper, 11 × 19 inches. The sitting monks are connected to philosophical words. From right to left, beauty, love, purity, peace, love, honesty (top), god, abundance (enrichment), and Buddha (blessings).

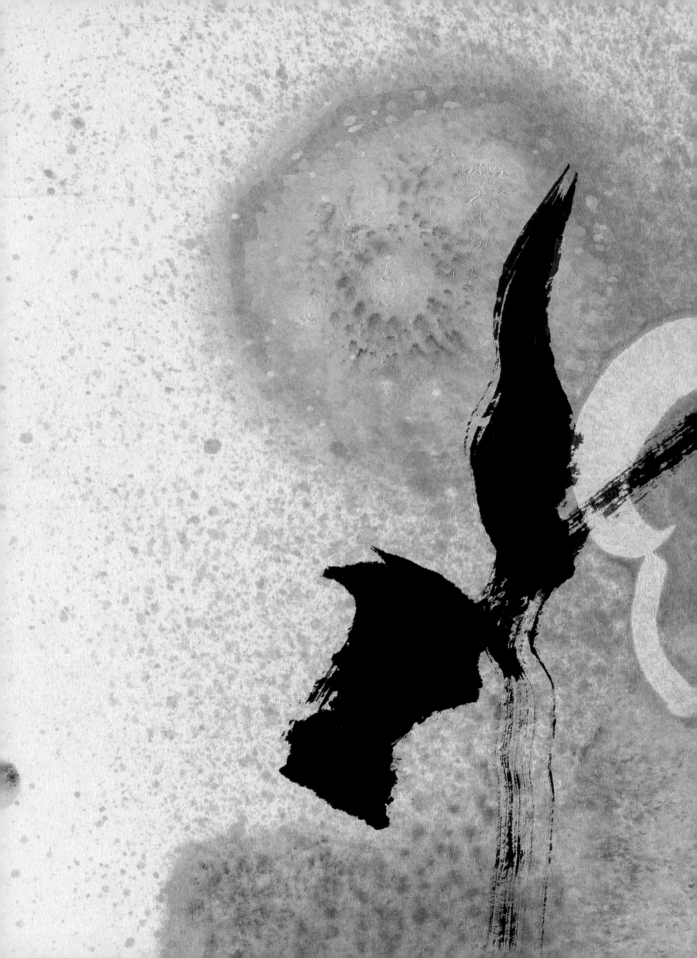

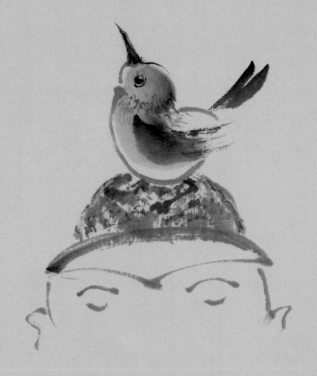

Life Again

sunny afternoon—
a one-legged robin
on the front lawn

—D.B.

Black Earth

My ideal nowadays is to extend the energy and beauty of brushwork passages to express what sumi ink can reveal. It's never predictable; the works take on their own direction. Sumi ink can be puzzling or even deceitful to both beginners and seasoned sumi artists. It's easy to lose control, and the results can be disappointing. But that is the challenge that keeps me going to the next project, the "what if?"

The word sumi is related to our Earth; in Japanese the word *kanji* is "black earth," the character for black atop the character for earth. I've been made aware that the Earth is a living entity that all sentient beings and plants inhabit. Sumi is processed outdoors mainly from charred pine tree and formed into a rectangular ink stick. The sticks are then ground by the artist's hand on a special smooth stone, the suzuri, such that the human spirit is said to be transmitted, forming "powerful liquid sumi ink." Thus sumi ink, made of black earth, becomes a living active agent. As I am painting, after I load the brush and make my strokes, black and gray tones appear. The beautiful colors of sumi. The more one finds the variety of tones, the more successful the painting will be, because in that variety exists emotional content and the viewer becomes more appreciative and empathetic.

For sumi artists in general, the intent is to capture the soul of the subject and to simplify it down to some essence. It is an intuitive activity

of immediacy. This means the artist will transmit the energy of his or her sensibility, channeling the essence in the shortest possible time. Inner and outer worlds are revealed and reconciled. Artist and nature interpenetrate, revealing a spiritual reality.

When I was in the fifth grade in Japan, no one pointed out the flowers in the garden, the clover growing on the side of the school yard, so green in color with bobbing white flowers. I just discovered the beauty of nature with happiness and wonder. When I returned to my birthplace, the United States, in 1947, and stayed briefly at my uncle's house, I found clover growing in his backyard. It was like finding a friend. I sketched the plant in my small notebook. I observed the white flowers, the many segments and intricate structure, and felt how beautiful they were. This was my first time sketching growing flowers.

In 2009 my husband Yosh passed away. I was seventy-nine. He had started smoking in the army when they gave out rations of cigarettes, and he kept smoking until he was forty, when his sons came home from school and said he would get cancer and made him stop. For half a year before his death he had trouble breathing and used an oxygen tank, and then one Sunday evening about 11 p.m. he woke me to say he couldn't breathe. I took him to the hospital. The nurse said his left lung was hard as a football. He stayed in hospital a few days, and stopped eating. On Friday the doctors sent him home, saying they couldn't do anything further and that he had two to three months to live. He still wasn't eating at home, but on a Sunday morning I made him his usual oatmeal, and he said it was oh so good and devoured the whole bowl. I thought things were looking up. But that afternoon he was dreamy and laboring to breathe, and suddenly he woke from his dreamy state and said, "I see a lot of people out there." I asked, "Do you know who they are? Can you make out the faces?" He answered, "I can't tell." Then he closed his eyes as if sleeping and his breath slowed and finally stopped. I was right there. This was the same week my daughter Jeanne was married by the ocean at Cannon Beach and so we missed the wedding.

Since that time I've lived alone and my artworks have taken over the house. Framed and unframed, in mats and not, they fill the living room, dining room, all the bedrooms, and garage, crowded on the walls, leaning against furniture, piled on tables, and in stacks. I have an exhibit on the walls of a Tai Chi studio in the Merlino Art Center, where I had a studio from 2002 to 2015, with a rotation of about fifty works on more or less permanent display. My studio is again in the house. I am free to fully do what I need to do for the rest of my life. I paint on many days and still teach classes. I write calligraphy and find new ways to portray the

"dragon" character. Characters are so flexible for expressive purposes. I study and draw eggs and bird nests, and imagine other approaches to Mokusen Saito's three-egg challenge. I read a lot of art periodicals and books to keep up with what is going on in the art world.

I have learned to tolerate a lot of things in my life, and still laugh, love nature, and find joy with brush and sumi, for its endless topics and ways to explore. I go for daily walks in my neighborhood whatever the weather, stepping outside to contemplate the birds, trees, rocks and flowers. Then I come home and jot down my ideas for painting. Sometimes I go into the backyard and weed for a while, or meet a cabbage white butterfly or spider, and whisper some words, communing with other sentient beings and clearing my mind for the next waiting task. On my walk today I was happy to meet a grasshopper. It was on the lawn, so I squatted down and talked softly. It jumped and flew as I watched, and returned to the grass some distance away. I remembered a grasshopper I'd encountered a little earlier. I am sure it is not the same one. Or could it be?

My artistic inspiration comes from the living, growing, roaming things of this Earth as well as seasonal changes and activities. I am anchored in the life of the Northwest with "Nisei hang-ups" washed away by the rainy seasons. I am a farmer's daughter, brought up planting rice shoots in the earth, wearing *waraji* sandals made of rice straw.

I am very mindful with food preparation. I freeze leftovers and eat them a week later. Little goes to waste. It's what I learned from being hungry as a child.

I choose to be generous, inspired by the generosity of the Hallens, and understand the pain of others: Mrs. Hallen, afflicted with whole body pain as I once experienced when my dress caught fire. I was angry at my father for his harsh words about my scars and cried a lot, but Mother was there to protect and comfort me. When I think of Father's cruelty and Mother's gentle solace, my eyes fill with tears. Then I laugh. Crying at nearly ninety, how silly. Through some strange chemistry I have learned to forgive and accept. And I have learned to accept mortality as well, with all arrangements in place with my female Zen priest for a Buddhist memorial with Christian aspects. I feel secure in having a life plan arranged.

I believe there are many ways to use sumi ink to express what is in the artist's mind and heart, and certainly there have been times when I've labored to construct a painting, or allowed accident to play a large role, or been inspired by words. My paintings are not overly concerned with representation as I use the ink to express inner thoughts and

sensibility, with inspiration from outer sources. My body is healthy. I hold the brush firmly to paint with ink ground from the ink stick, full of spirit. I have learned to use tools from a household broom to Q-tips. I don't feel the need to follow traditional ways. Why not toss "black earth" and observe the result on rice paper? What image is produced? Is it only the splash? Is there more to be explained by new observation? What if I were to use a hair dryer and chase the sumi tossed in air toward the hanging rice paper? (next week's project). The spirit of exploration is the most important element for aspiring as well as for seasoned artists to move forward to another level of understanding and progress. With patient practice one in time becomes fearless, and finally the artist has been rescued by the sumi ink.

Opposite
Compassion, circa 2015, ink and watercolor on paper, 18 × 14 inches. The black character is compassion. The white characters are pictograms for enlightenment. The idea is, enlightenment turns into compassion. In this series I was trying to combine Western and Eastern approaches. Calligraphy is Eastern, the background more Western or Platonic with the basic underlying geometries of rectangle, triangle, circle, and sphere.

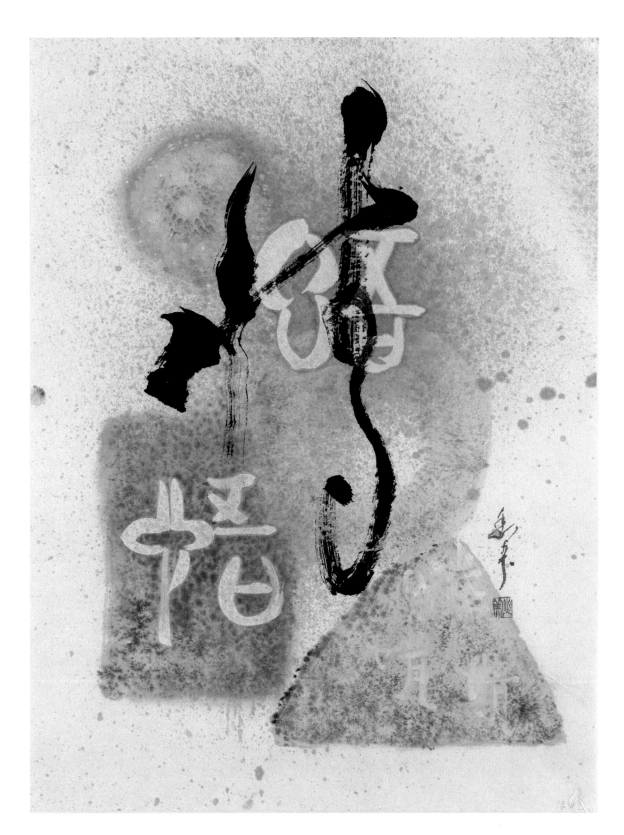

Note on Process

This book was a collaboration between Fumiko Kimura and David Berger. Fumiko had long wanted to create some kind of memoir. David had become familiar with parts of Fumiko's story as a fellow member of Puget Sound Sumi Artists (PSSA). He was intrigued and being a writer as well as an artist he offered to help. The manuscript was prepared by David in collaboration with Fumiko from her snippets of writing and interviews conducted over the course of nearly two years, and from her diaries, edited for readability.

David enjoys writing haiku, and while working on the manuscript with Fumiko he found himself responding to her story with haiku poetry. They ultimately decided to incorporate some of those short poems into the manuscript. Combining haiku poems with prose follows the Japanese literary tradition known as haibun.

Haiku

—D.B.

a bent shoot
rises through the morning mist
springtime

father's cutting words
she hides
in mother's kimono

an empty sky
her stomach growls
in the rice field

. . .

pungent pine mushrooms
right at her husband's feet
the laughter of American crows

grinding sumi ink on stone
lost in circles
of repetition

visiting Japan
the warm breeze
so familiar

she makes dinner and money
each night
the dark sky

the hum
of the temple bell
— the color of ripe grapes

full moon
she urges the students
to notice

looking at ink
finding the croak and long toes
of frogs

. . .

sunny afternoon —
a one-legged robin
on the front lawn

again this morning
a walk to do nothing
and everything

into waiting hands
she presses two persimmons
departure

Exhibitions and Bibliography

Fumiko Kimura b. 1929
lives in Tacoma, WA

Education 1985 Kyoto Nanga School, Kyoto, Japan
1977 MA, Art Education, University of Puget Sound, Tacoma, WA
1954 BS, Chemistry, College of Puget Sound, Tacoma, WA

Selected Collections Microsoft Corporation, Redmond, WA
Tacoma Art Museum
Pierce County–Main Library, Tacoma
University Place Library, Tacoma
Columbia Bank, Tacoma
University of Puget Sound–Department of Religion, Tacoma
Harborview Hospital, Seattle
Swedish Hospital, Seattle
Group Health–Bellevue, WA
Washington State History Museum, Tacoma
Pennwalt Corporation, Tacoma
Lyle Wood Products, Tacoma
Nalley's Fine Food, Tacoma
Security Pacific Bank, Tacoma
Weyerhaeuser Company, Seattle
Port of Tacoma
Plum Creek Timber Company, Fisher Properties, Seattle
City of Tacoma 1% for Art
Husky Terminal and Stevedoring, Inc., Tacoma
Benihana Inc., Aventura, FL

Selected Solo Exhibits

2019 *Haiga & Mixed Media Paintings*, Asia Pacific Cultural Center, Tacoma

2019 *Haiga Paintings*, Seattle Japanese Garden, Seattle

2017 *One.Dot.Sumi*, Kittredge Gallery, University of Puget Sound, Tacoma

2014 *Fumiko Kimura Retrospective* (50 years), The Gallery, Tacoma Community College

2012 *Poetry of Tea Bag*, Flow Gallery, Tacoma

2010 *New Work*, Living Gallery, Ashland, WA

2008 *Alchemy of Glued-on Treasure*, Wing Luke Museum, Seattle

2006 *Scent of Sumi,* The Living Gallery, Ashland, WA

2006 *Sumi Art & Sumi/Collage*, Childhood's End Gallery, Olympia, WA

2005 *Journey Through the Portal*, Washington State History Museum, Tacoma

2005 *Connecting the Past with the Present*, American Art Company, Tacoma

2002 *Family Renewal*, Handforth Gallery, Tacoma Public Library

2000 *Rediscovered Images*, Living Gallery, Ashland, WA

1999 *Enduring Dao*, American Art Company, Tacoma

1999 *New Works*, Bainbridge Arts & Crafts, Winslow, WA

1997 *Clearcut*, Kyoto International Cultural House, Japan

1995 *Harmony in Conflict; Forest Phoenix*, Washington State History Museum, Tacoma

1993 *Wounded Forest*, Seattle University Gallery

1988 *New Works*, Wing Luke Museum, Seattle

1986 *Northwest Landscapes*, Evergreen State College, Olympia, WA

1984 *Recent Works*, Handforth Gallery, Tacoma Public Library

1983 *Scent of Autumn*, Evergreen State College, Olympia, WA

1983, 1982 *New Works*, OC Art Gallery, Olympic College, Bremerton, WA

1981 *Acrylics Reinvented, Trials on Canvas with Artist-made Acrylics*, Pacific Lutheran University, Tacoma

1973 *Northwest & Local Scenes*, Washington State History Museum, Tacoma

1965 *Scenes and Flowers*, Sumi/watercolors, Washington State History Museum, Tacoma

1963 *Miniatures in Sumi*, Tacoma Public Library

1961 *Watercolors*, Washington State History Museum, Tacoma

Selected Group Exhibits	2019	*Pacific Sunset*, Tacoma Art Museum
	2012–2018	International Kakyou Calligraphy Exhibition, National Museum, Tokyo (annual participation)
	2013	*Puget Sound Sumi Artists: Breaking Tradition*, Moses Lake Museum and Art Center, Moses Lake, WA
	2013	*Shodo*, Handforth Gallery, Tacoma Public Library
	2001, 1995, 1987, 1984	Biennial Competition, Tacoma Art Museum
	1991, 1990	Plaza Perspective Gallery, SeaFirst Building, Seattle
	1990	Oriental Brushwork Society of America, Oklahoma City, OK
	1989–2001	National Sumi Society of America, Washington, D.C. (annual participant)
	1989	Mixed Media Exhibit, Husted Gallery, Seattle
	1988	*Sumi Neo Tradition*, Bumbershoot Arts Festival, Seattle
	1988	*Six Northwest Contemporary Sumi Masters*, Bellevue Art Museum, WA
	1987	*Women Painters of Washington*, Kobe and Tokyo
	1987	*Tacoma Printmakers*, University of Puget Sound, Tacoma
	1986, 1979, 1978	Puget Sound Area Exhibit, Frye Museum, Seattle
	1985, 1984	UPS Faculty, Tacoma Art Museum Faculty Exhibit, Tacoma
	1984, 1979, 1977	Washington Open, "Painting & Sculpture," Tacoma Art Museum

Selected Awards	2019	"Haiga Exhibit and Demonstration," Tacoma Artists Initiative Program
	2013	First Place Award, *Puget Sound Sumi Artists: Breaking Tradition*, Moses Lake Museum and Art Center, Moses Lake, WA
	2013	Third Place Award, "International Calligraphy (Shodo)," Handforth Gallery, Tacoma Public Library
	2013	First Place Award, "Watercolor," Washington State Fair, Puyallup
	2010	"New Works, Artist-Made Sumi Ink," Tacoma Artists Initiative Program
	2007	Third Place Award, International Society of Sumi Artists
	2005	"Return to Creativity," Project Grant, Western Watercolor and Asian Brush Calligraphy, Bainbridge Island, WA
	2002	"Family, Use of Gouache in Preparation for an Exhibit," Tacoma Arts Commission, Tacoma Public Library
	2001	First Place Award, *Forest Festival #3*, National Sumi Society of America
	2001	"After Many Summers," Tacoma Artists Initiative Program
	1997	*Beginners Sumi Book*, Agility Fund, Tacoma Arts Commission

1994 "Clearcut" Project, Artist Trust GAP Fund Award

1993 Honorable Mention, Northwest Poets & Artists Competition, Bainbridge Island, WA

1992 Merit Award, Northwest Watercolor Society Annual

1990 Olive Carl Memorial Award, Women Painters of Washington Juried Show, Kirkland

1989 Judges Merit Award, North Coast Collage Society Annual, Everett, WA

1989, 1987 First Place Award, "Asian Calligraphy," Puget Sound Sumi Artists Washington Open Exhibit, University of Puget Sound, Tacoma

1989 Merit Award, Visual Arts Professional Division, 43rd Annual Northwest Arts & Crafts Fair, Bellevue Art Museum, WA

1989 First Place Award, *Plum Blossom*, National Sumi Society of America Annual

1988 "1988 Artist of the Year for Outstanding Contribution to the Visual Arts," Pierce County Arts Commission, Tacoma

1988 Judges Merit Award, North Coast Collage Society Annual, Hiram, OH

1987 Best of Show, "Watercolor," Washington Open, National League of American Pen Women, Tacoma

1986 1% for Art Award, Tacoma

1985 Woman of the Year Award in Arts & Communications, "For . . . Active Role in Oriental Sumi Painting," Tacoma YWCA

1983 Merit Award, Pacific Northwest Arts & Crafts Fair, Bellevue Art Museum, WA

1981, 1977, 1975 Honorable Mentions, Northwest Watercolor Society Annuals

1980 Merit Award, National League of American Pen Women, Washington, D.C.

Selected Bibliography

2014 "Two Artists Work at Synthesis Between Art of Japan and America," Dave R. Davison, *Tacoma Weekly*, Nov. 28.

2012 "Poetry of Tea Bag Art," Rosemary Ponnekanti, *Tacoma News Tribune*, Nov. 19, p. 1.

2010 "Three Asian Artists," *Volcano* [Tacoma Community College].

2009 "Paint and Paper Evoke Deep Emotion in Zen Tradition," Roselle Kingsbury, *City Collegian* [Seattle Central Community College], Apr. 14, p. 5.

2008 "The Hills are Alive," David Domkowski, *City Arts Magazine*, July, p. 38.

2007 "Sumi & Sumi/Collage," Patty Coomes, *Cannon Beach Gazette*, Summer.

2006 "Rediscovered Images," Vickie Aldous, *Ashland Daily Tidings*, June 15, p. 10.

2004 "A Brush with the East," Jessica Sattell, *Internationalist* [University of Puget Sound] 2, no. 2.

2003 "Fumiko Kimura," *International Artists* 31, June/July.

2002 "Creatively Connected," Jen Graves, *Tacoma News Tribune*, Mar. 24, p. 6.

1995 "Forest's Destruction, Rebirth Feeds Artist's Imagination," Leslie Holdcroft, *Tacoma News Tribune*, July 14.

1995 "Art and Ballet a Good Mix, Tacoma City Ballet, Kimura as Stage Designer," Gil Blas, *The Tacoma Weekly* 5, no. 20, June.

1995 "Moving Day Approaches: Harmony in Conflict: Forest Phoenix," *The Seattle Times*, Sept. 21, p. D-26.

1995 "Simply Sumi," Bill Timnick, *Tacoma News Tribune*, June.

1993 "Artist Profile: Fumiko Kimura," Jennifer Teunon, *Newsletter of the Cultural Resources Division, City of Tacoma* 1, no. 1, May/June.

1993 "From Fury to Fusion," *Tacoma News Tribune*, Mar. 4.

1992 "A Pas de Deux—and then some," Keith Raether, *Tacoma News Tribune*, Feb. 25.

1992 "Sumi Art," Lock Adamson, *Journal of American Art*.

1990 "Sumi Art," Keith Raider, *Tacoma News Tribune*.

1987 "Fumiko Kimura," Bobby Vanskiver, *Signature, the Northwest Art Magazine*, Oct., p. 3.

1985 "Fumiko Kimura's Collages Are Paradoxical, Brilliant," Warren B. Wotton, *Tacoma News Tribune*, Nov. 17, p. B-15.

Acknowledgments

There are many people to thank for helping make this book possible. Fumiko was greatly encouraged by her brother George Takahashi and also her daughter Jeanne Young. They both deserve hearty appreciation. Fumiko's many friends, including Robert and Voski Sprague, as well as her colleagues at Puget Sound Sumi Artists, were all steadfast in their support and enthusiasm.

As the manuscript took shape, various readers gave feedback, including Fumiko's daughter-in-law Marcia Kimura and son Richard Kimura, son-in-law Mark Young, Jessica Dodge, Jim O'Shea, Cathy Toshiro, and Karen DeWinter. Their perspectives were invaluable. Michelle Schaefer, a past president of Haiku Northwest, generously offered her comments on the haiku.

Barbara Tackett, Jeanne Young, and Barbara Mizoguchi Asahara were great helps in facilitating the photo shoots. Steven Miller was the primary photographer, with additional photos by Donna Trent and Michael Dylan Welch. We are grateful to the collectors who were willing to lend their pieces for photography, including Gary and Lavina Bodhaine, John Butler, Georg and Nina Pedersen, Barbara Tackett, George Takahashi, Bernice Vincent and B. J. Vincent, Rev. Bob and Michie Yamashita, Lois Yoshida, and Tacoma City Ballet (with Belle Schwanger modeling the leotard). Some drawings of small animals were first published in *bug-eyes & bird-brained: small creature haiku* by Rick Clark. David Lobban took the picture of Fumiko demonstrating.

A project like this takes many oars to move forward, and we are deeply appreciative to all who offered support and encouragement.

Index

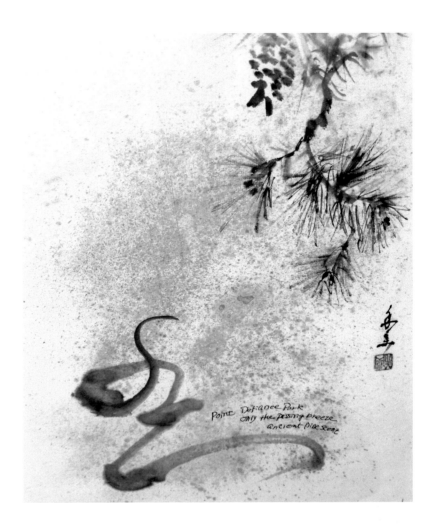

Scent of Pine, 2019, ink and watercolor on paper, 13 × 11 inches. The poem reads: *Point Defiance Park / only the passing breeze / ancient pine scent*. The curving line in the lower corner is an adaptation of the Japanese character for scent.

Library of Congress Control Number: 2019951485
ISBN: 978-1-63405-008-1

PUBLISHED BY CHIN MUSIC PRESS, SEATTLE
www.chinmusicpress.com

PRODUCED BY LUCIA | MARQUAND, SEATTLE
www.luciamarquand.com

Designed by Thomas Eykemans
Typeset in Warnock Pro by Maggie Lee
Proofread by Elissa Greisz
Indexed by Richard Carlson
Color management by iocolor, Seattle
Printed and bound in China by Artron Art Group

the hum of the temple bell and *an empty sky* haiku poems first published in the 11th Yamadera Bashō Memorial Museum Haiku Contest (2019).

IMAGE CREDITS

Inside cover: Detail, *One Dot Sumi*, 2017, ink on paper, 11 × 19 inches (see page 137).

Frontispiece: Detail, *Waterfall of the Mind*, 2013, ink and paper collage on paper, 16 × 13 inches (see page 103). The poem is by Saigyō, a 12th-century Japanese poet. It translates as:

The mind for truth
Begins like a stream, shallow
At first, but then
Adds more and more depth
While gaining greater clarity
(William R. LaFleur, trans.)

Page 6: Fumiko Kimura demonstrating painting at Bainbridge Island Arts & Crafts Gallery, 2013. Photo credit David Lobban, Lobban Photography, Inc.

Pages 12–13: Detail, *In The Beginning* ("Microcosm" series), early 2000s, ink and watercolor on paper, 13 × 23 inches

Pages 74–75: Detail, *Welcome (Waving Frog)*, 2016, ink and watercolor on paper, 6½ × 7½ inches

Pages 138–139: Detail, *Compassion*, circa 2015, ink and watercolor on paper, 18 × 14 inches